Self-portrait of

. .

A DAVID & CHARLES BOOK

Originally published in France as Petit Cahier de Griffonnage Special Mode

First published in the UK and USA in 2014 by F&W Media International, Ltd

David & Charles is an imprint of F&W Media International, Ltd
Brunel House, Forde Close, Newton Abbot, TQ12 4PU, UK

F&W Media International, Ltd is a subsidiary of F+W Media, Inc
10151 Carver Road, Suite #200, Blue Ash, OH 45242, USA

A catalogue record for this book is available from the British Library.

ISBN-13: 978-1- 4463-0454-9 paperback
ISBN-10: 1- 4463-0454-X paperback

Printed in China by RR Donnelley for:
F&W Media International, Ltd
Brunel House, Forde Close, Newton Abbot, TQ12 4PU, UK

10 9 8 7 6 5 4 3 2 1

Editorial: Colette Hanicotte
Illustrations: Annabel and Violette Bénilan
Layout and cover design: Violette Bénilan
Production: Anne Raynaud

F+W Media publishes high quality books on a wide range of subjects.
For more great book ideas visit: www.stitchcraftcreate.co.uk

Violette Bénilan : graphic designer and illustrator : www.violettebenilan.fr
Annabel Bénilan : stylist, fashion designer and illustrator : www.annabelbenilan.blogspot.fr

the fashion doodle book

D&C
David and Charles

For our brother, Gaspard

« There are flowers everywhere, for those who »
bother to look

Henri Matisse

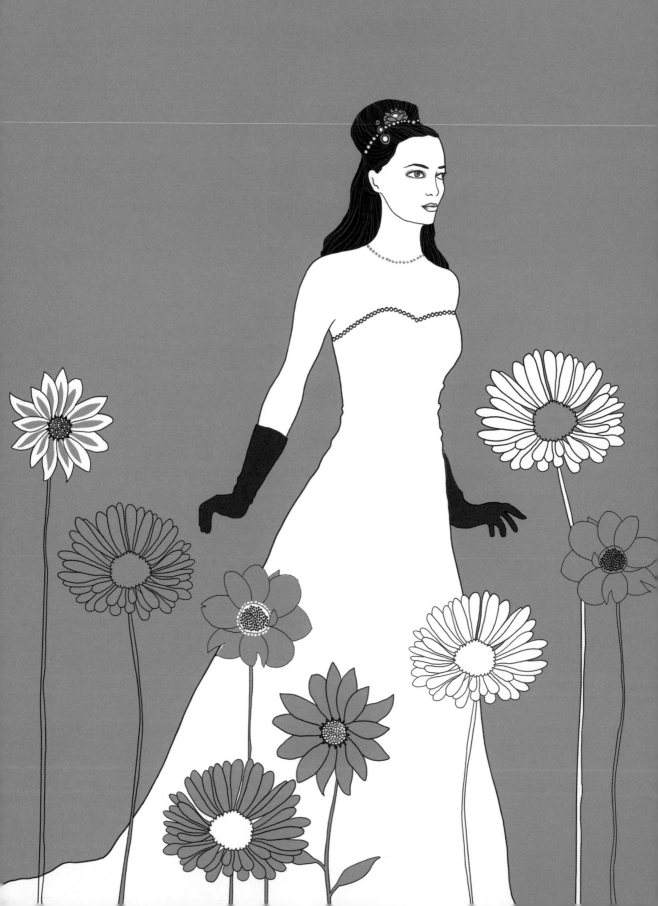

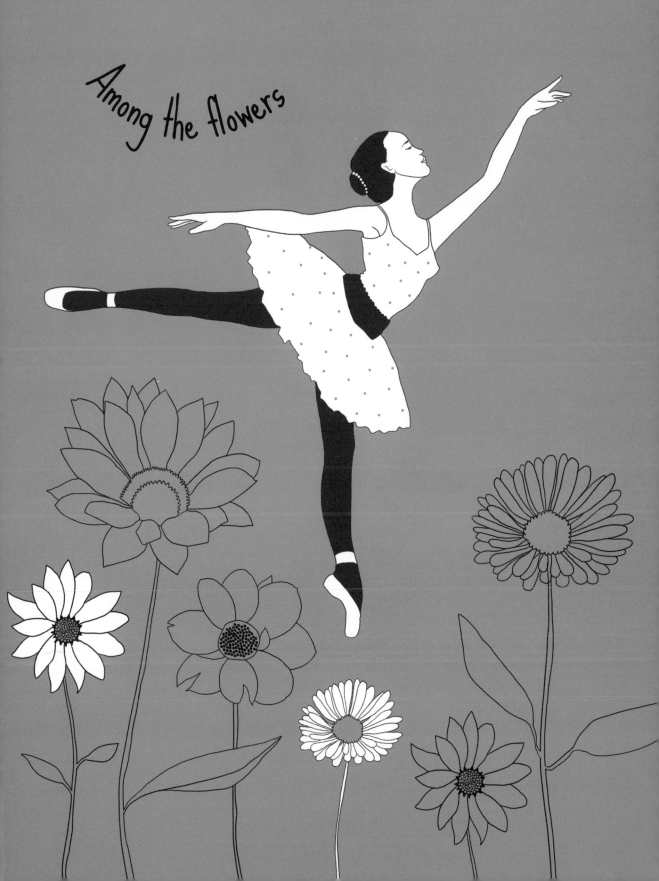

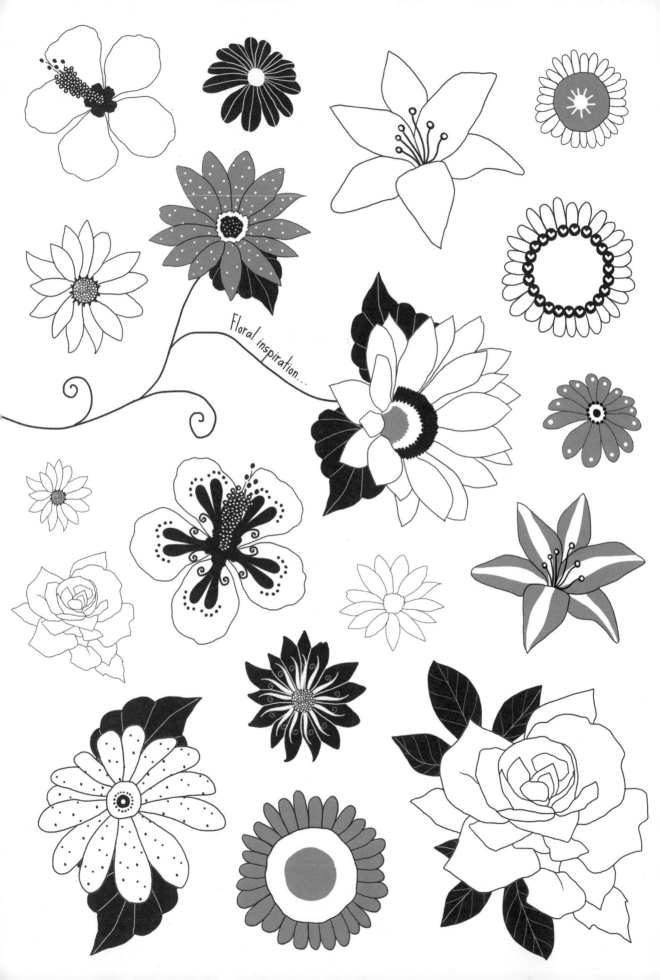

Floral inspiration...

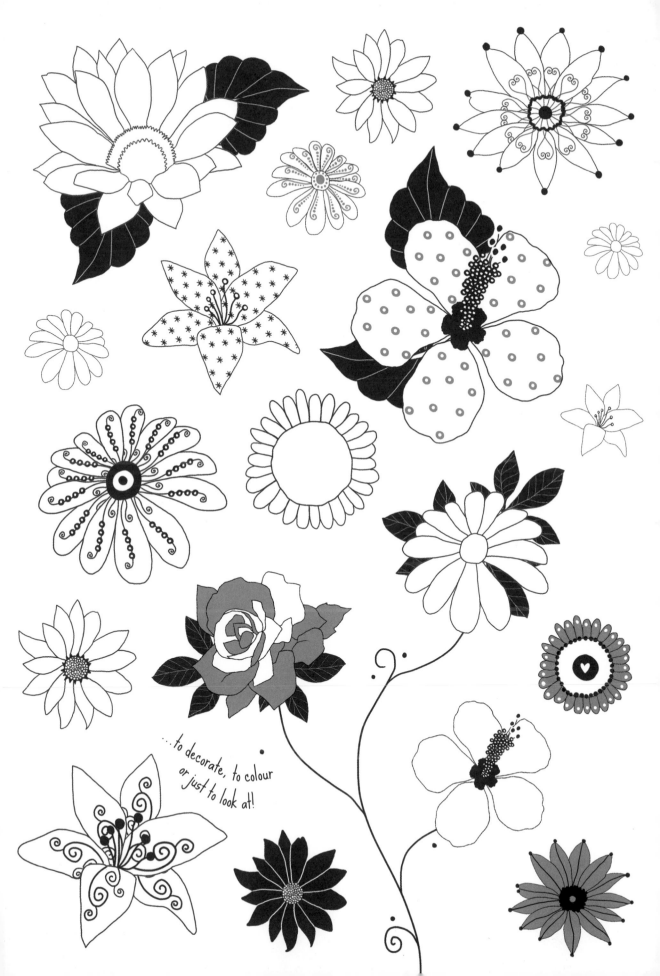

...to decorate, to colour or just to look at!

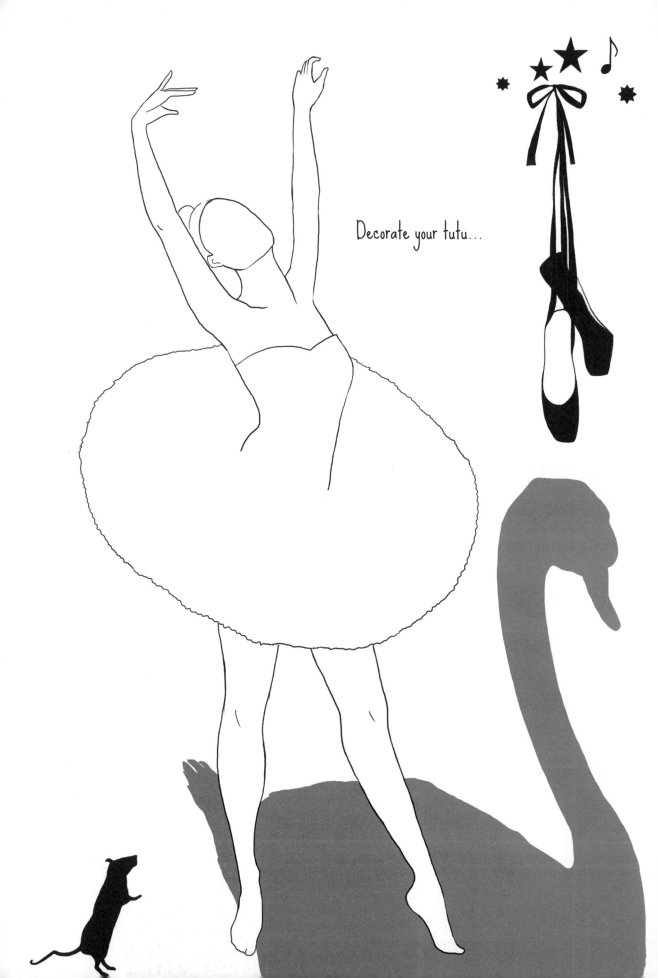

Decorate your tutu...

and then DANCE!

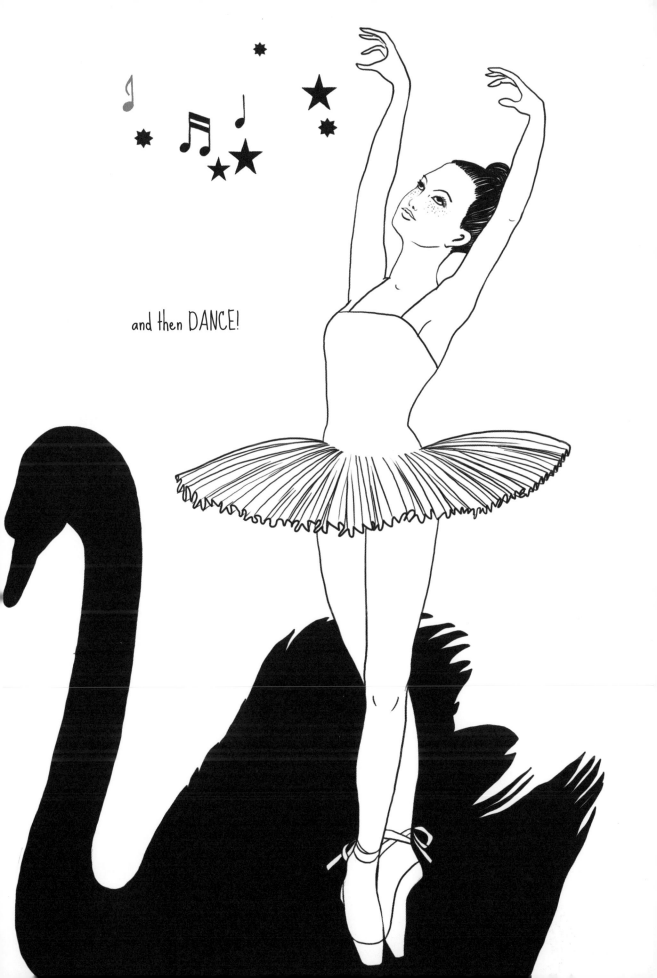

Scribble and doodle
on the telephone

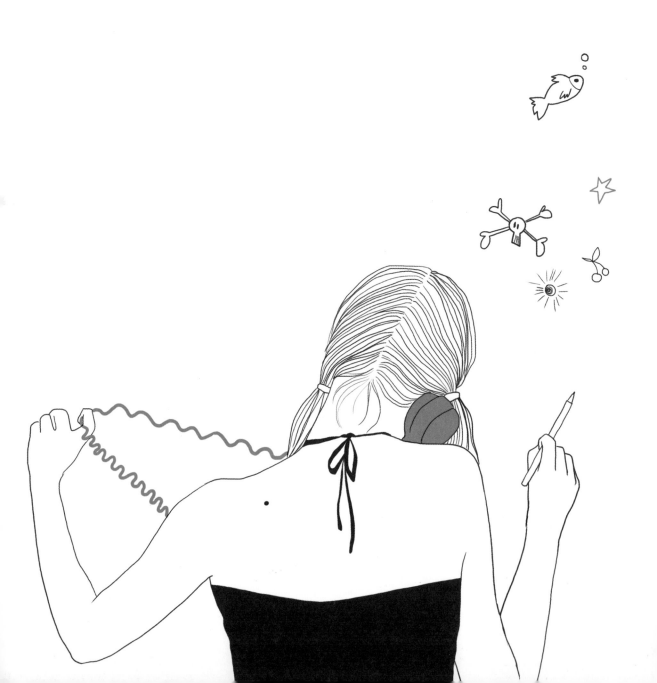

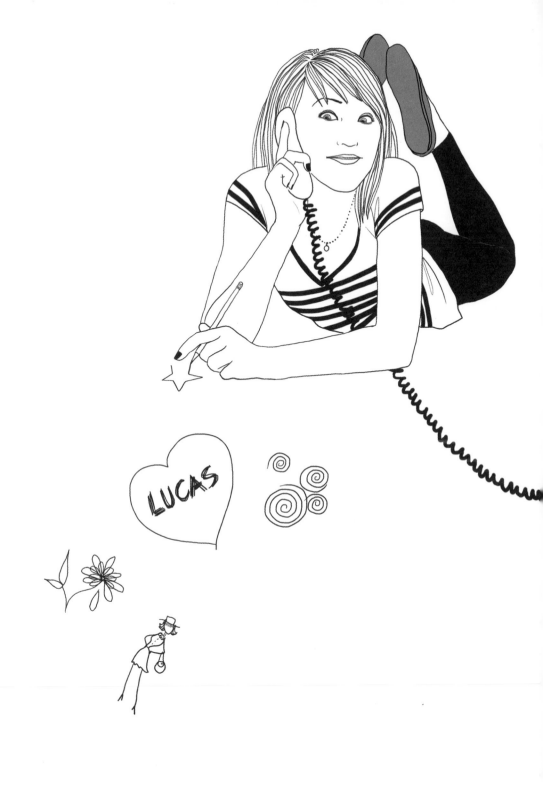

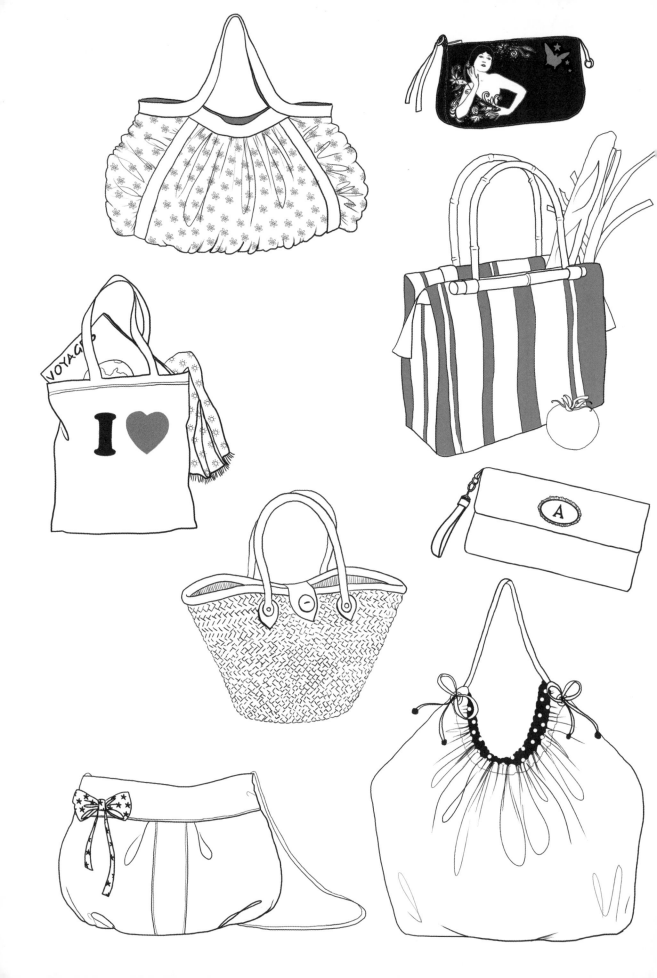

Design a bag for
every occasion

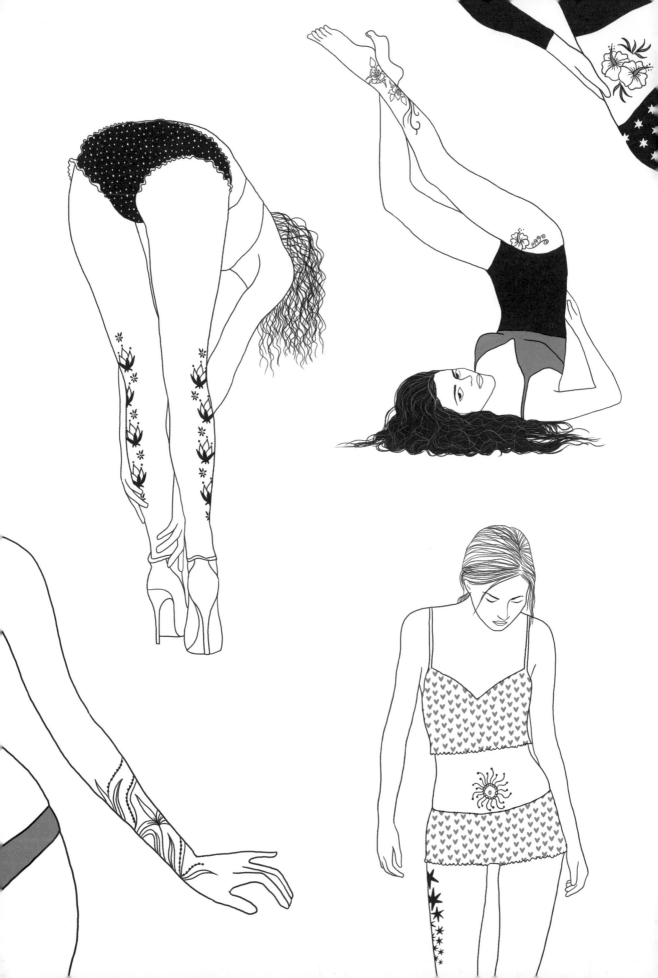

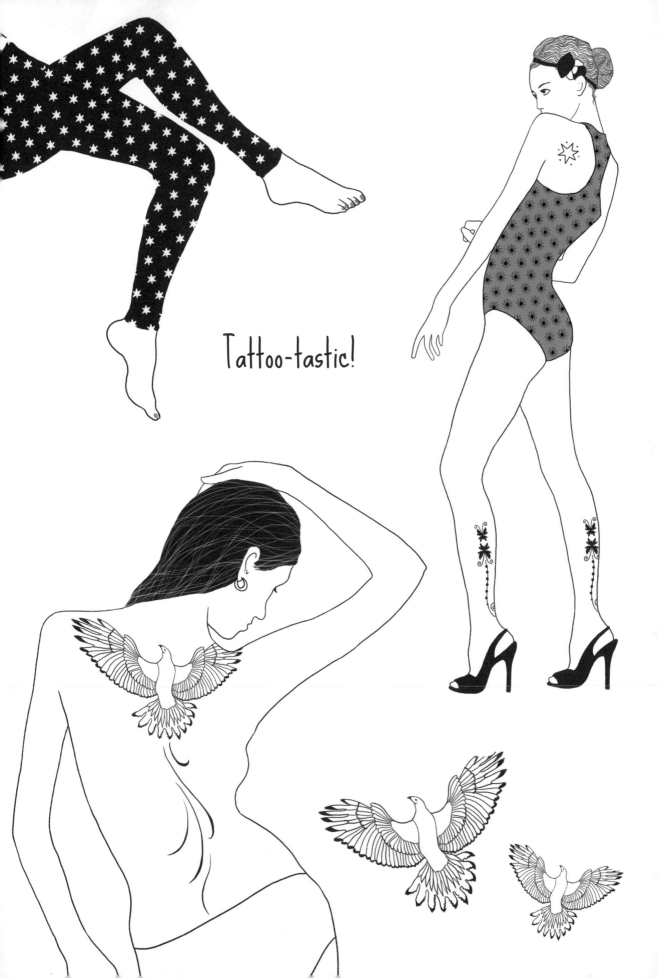

Tattoo-tastic!

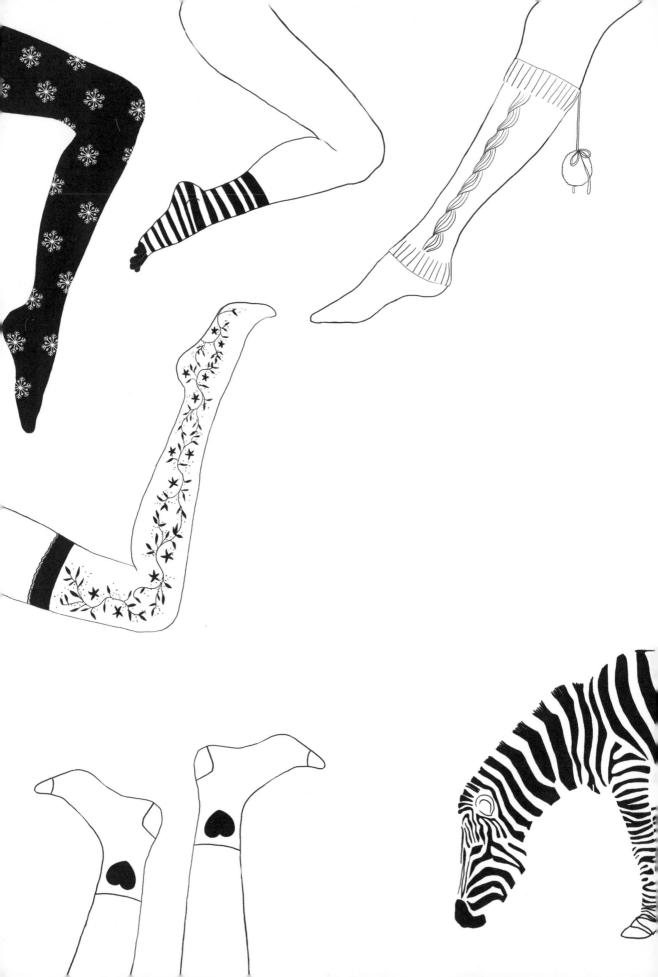

Be inspired to design your own socks...

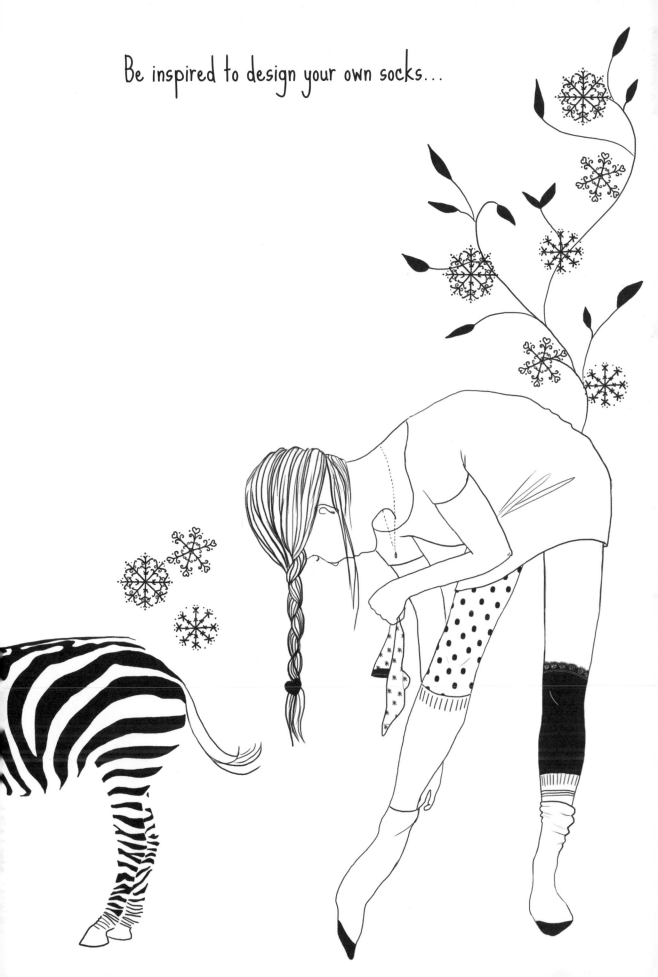

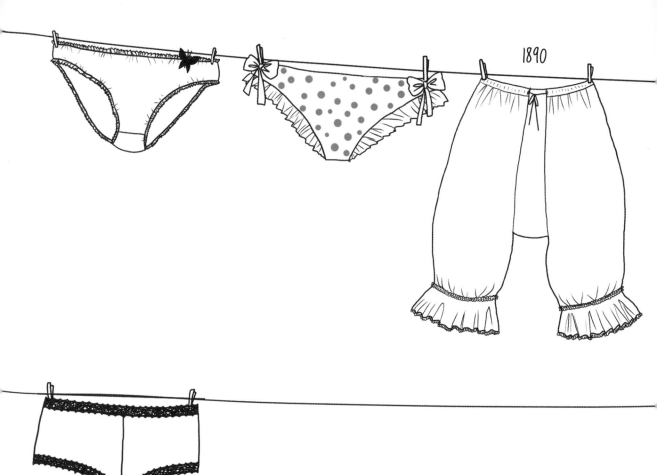

1890

Knickers through the ages

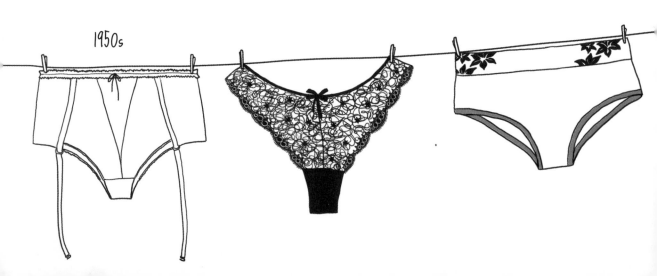

1950s

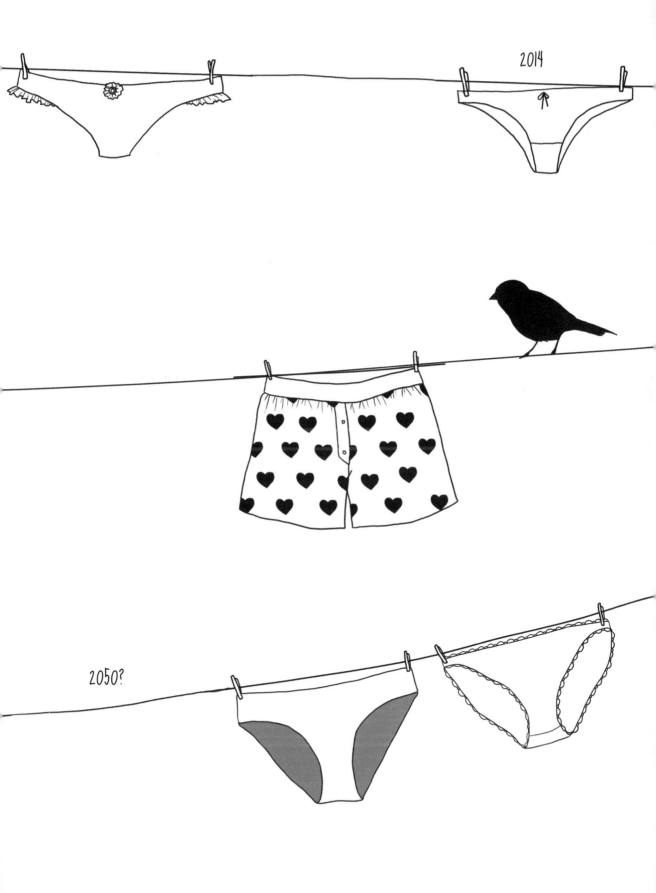

2014

2050?

Cut out the black and white CLOTHES
opposite to dress this PRETTY girl

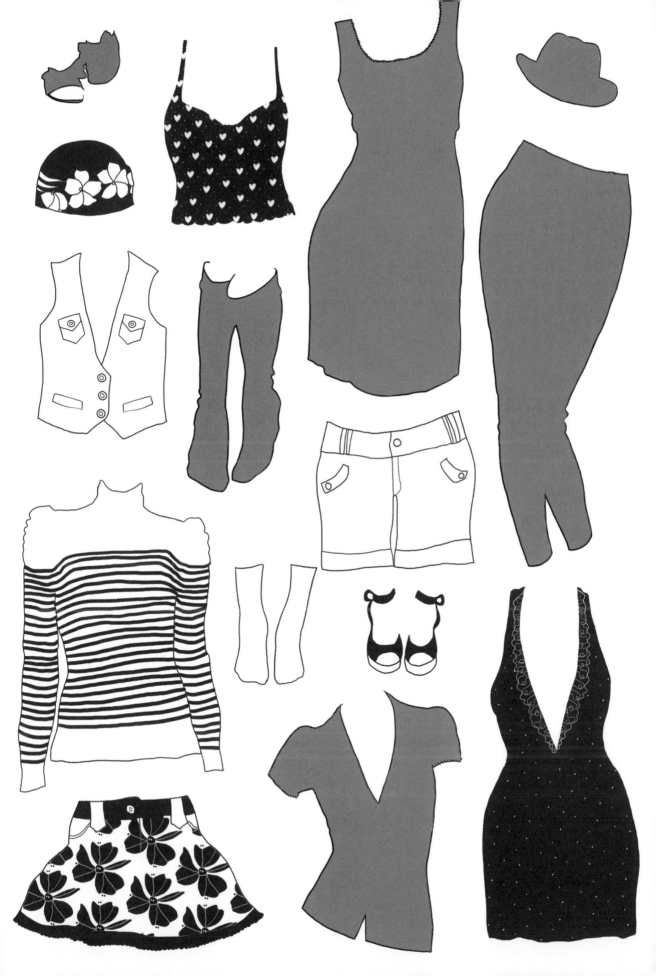

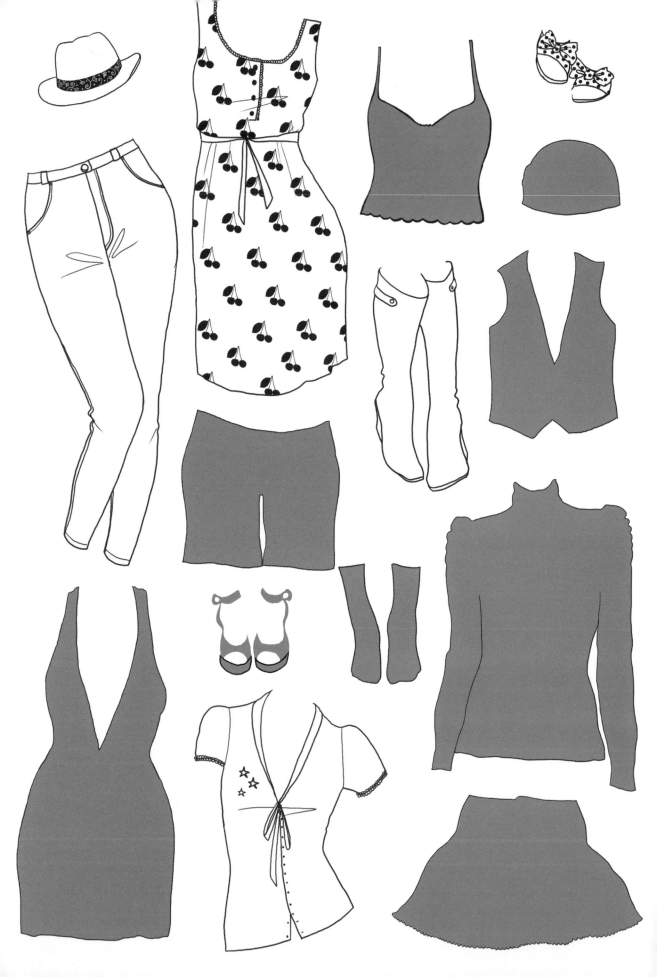

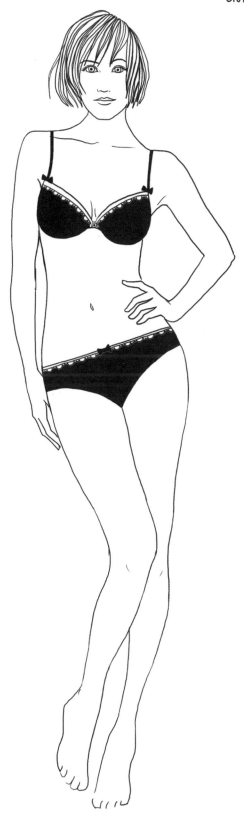

Decorate the clothes with patterns

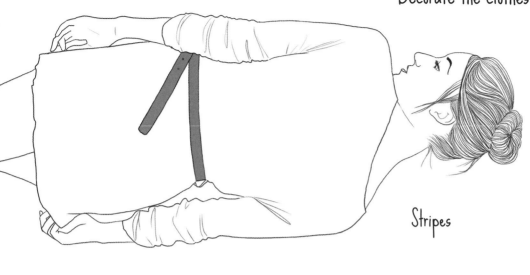

Stripes

Flowers

Hearts

Stars

Spots

Freestyle!

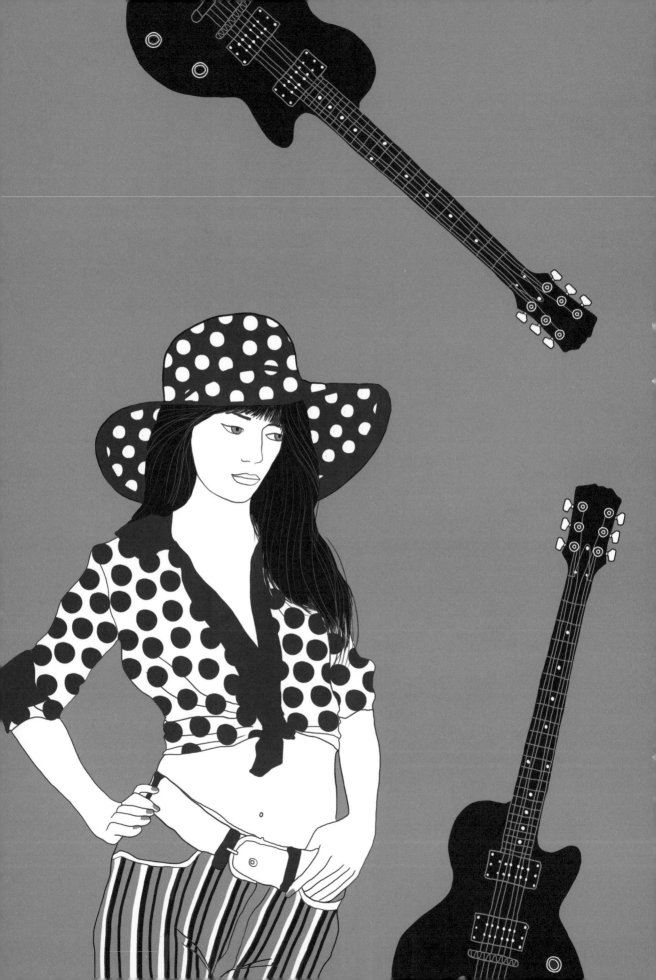

Swinging Sixties Style!

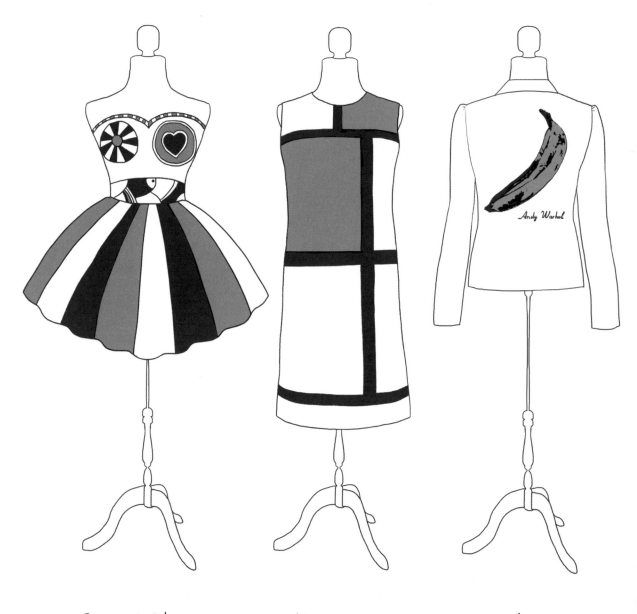

Inspired by Niki
de Saint Phalle

«Mondrian Dress»
YSL 1965

Silk Screen
POP ART

DIAMONDS are a girl's BEST FRIEND

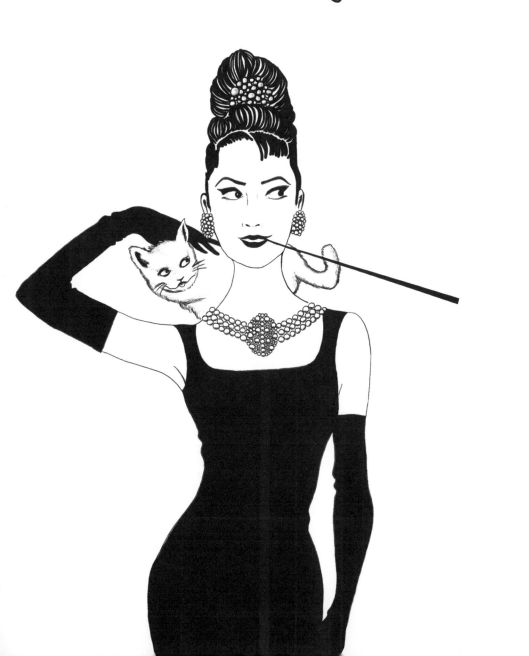

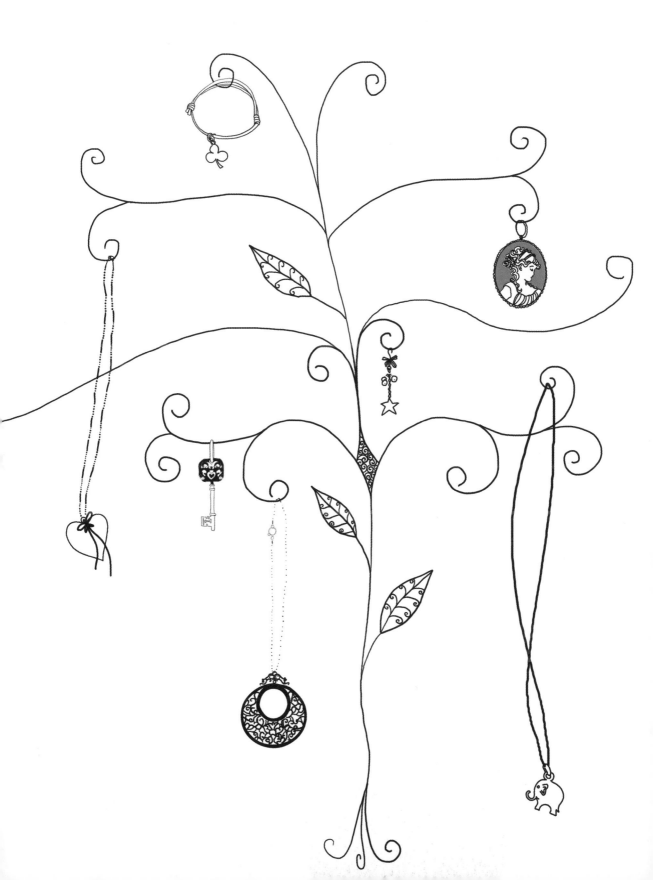

Grow some more jewellery

The silhouette of

① The shoe of

.......................

Know your fashion classics!

The SUPER-COOL
hairstyle of
..........................

3

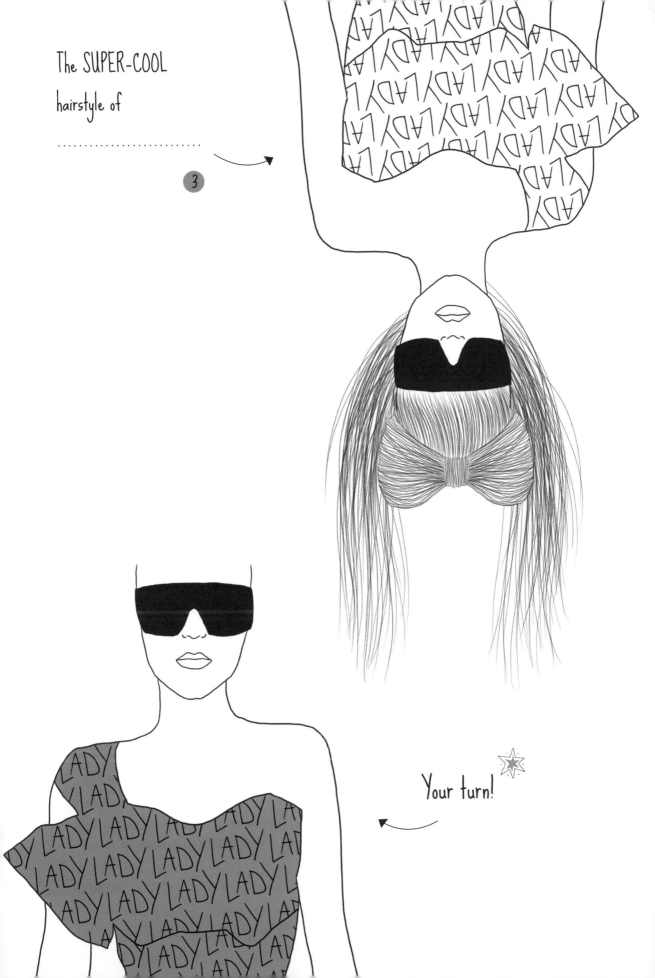

Your turn!

Lunch with the STARS

Name the celebrities who
have swapped shoes

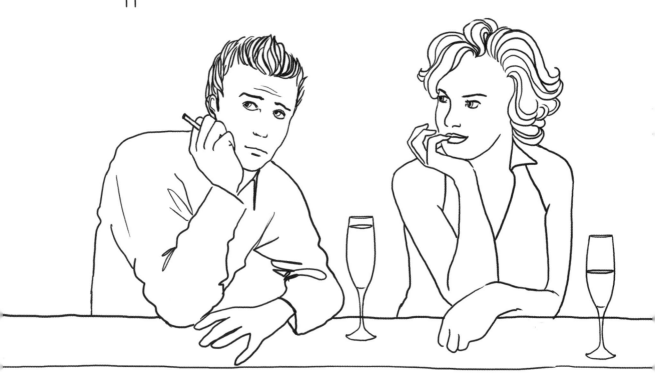

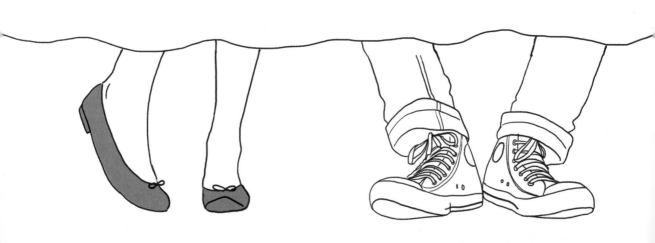

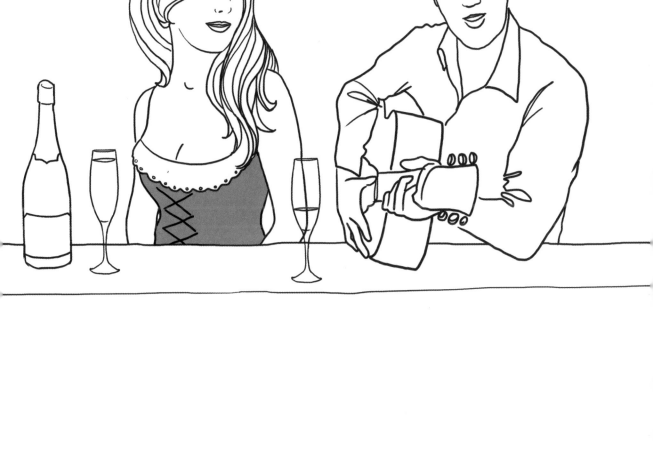

Design more LOVELY shoes

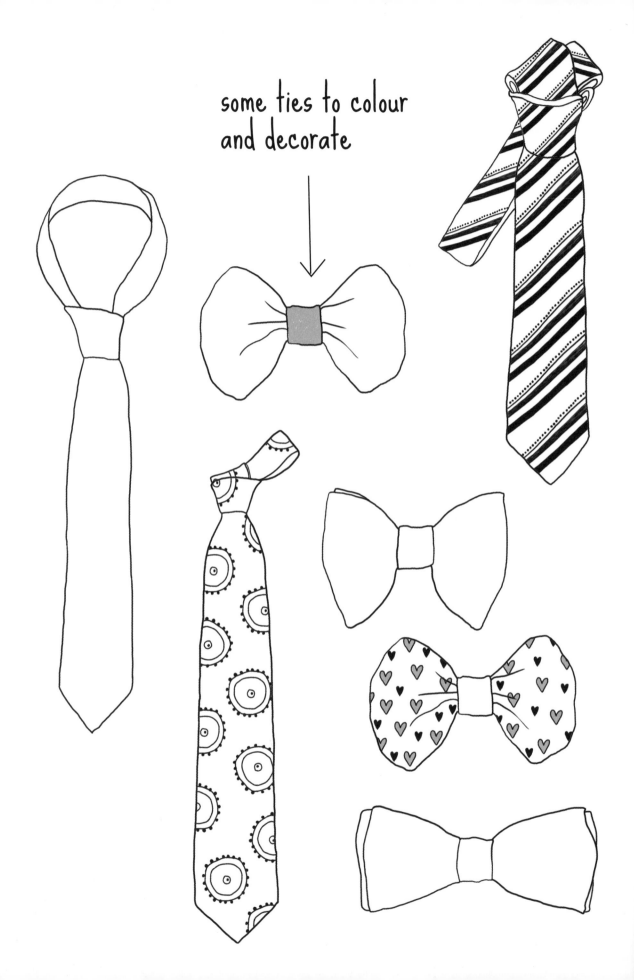

some ties to colour
and decorate

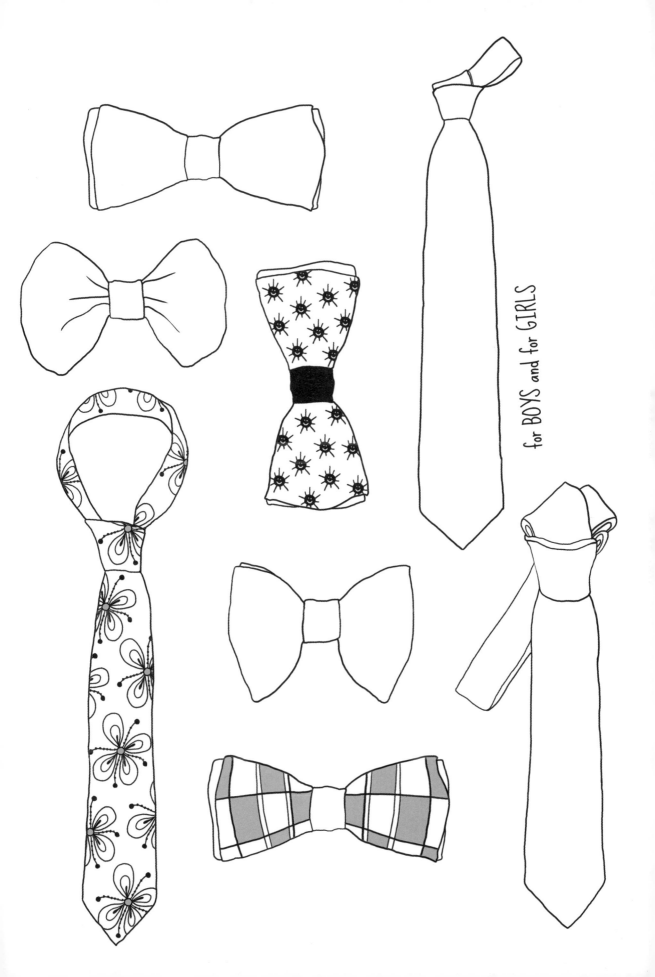

for BOYS and for GIRLS

Girls just want to have fun!

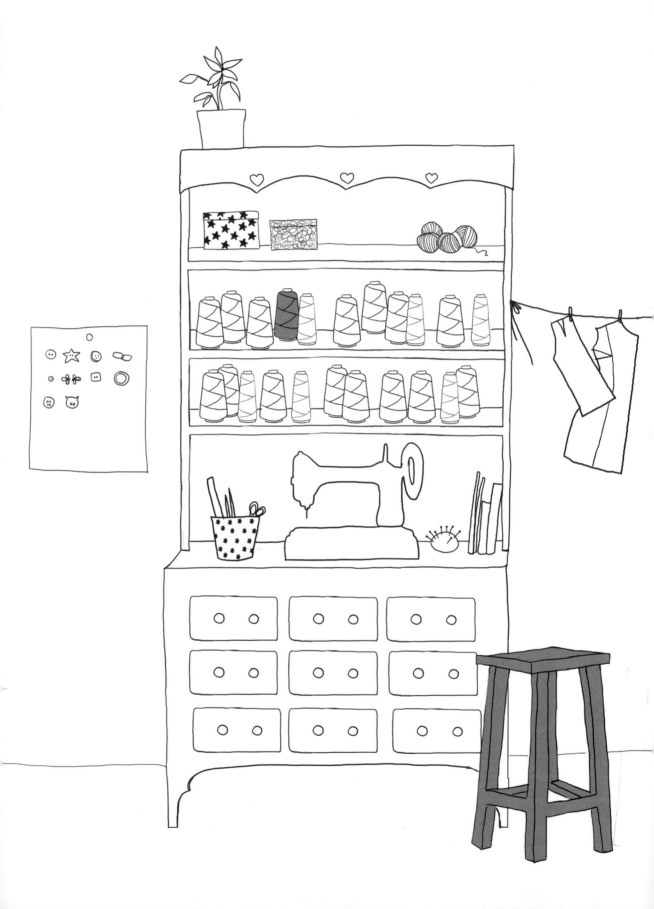

Brighten up this haberdashery heaven!

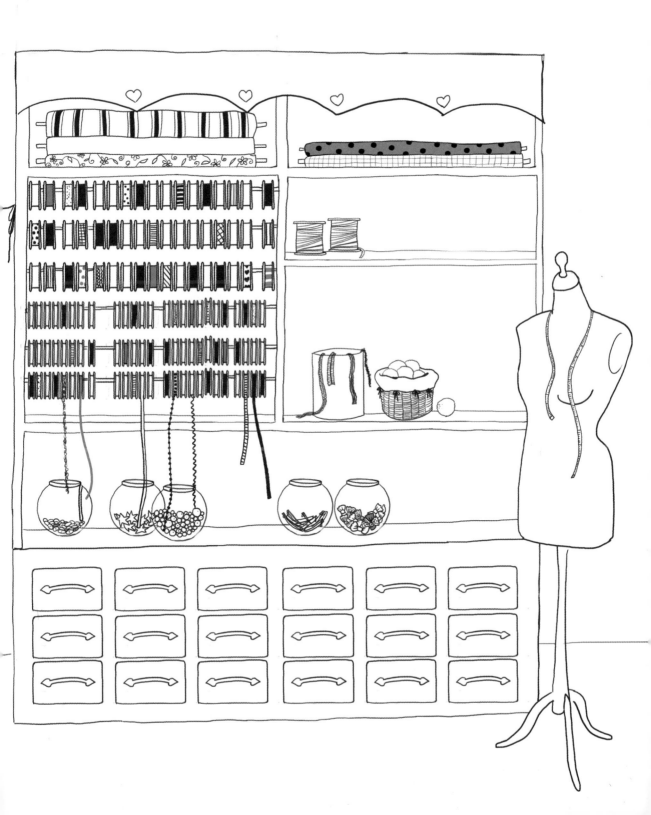

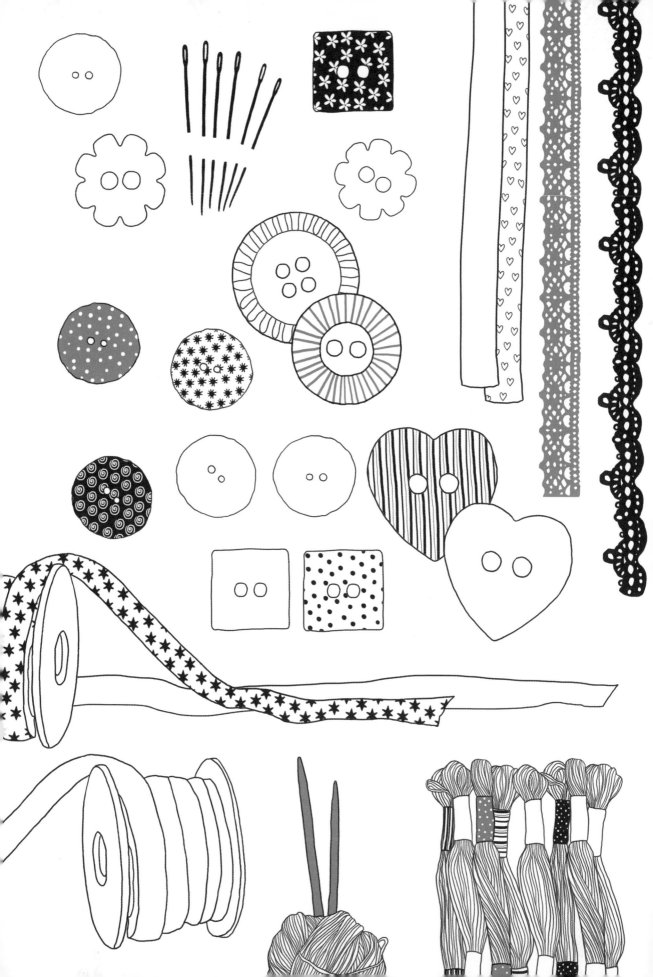

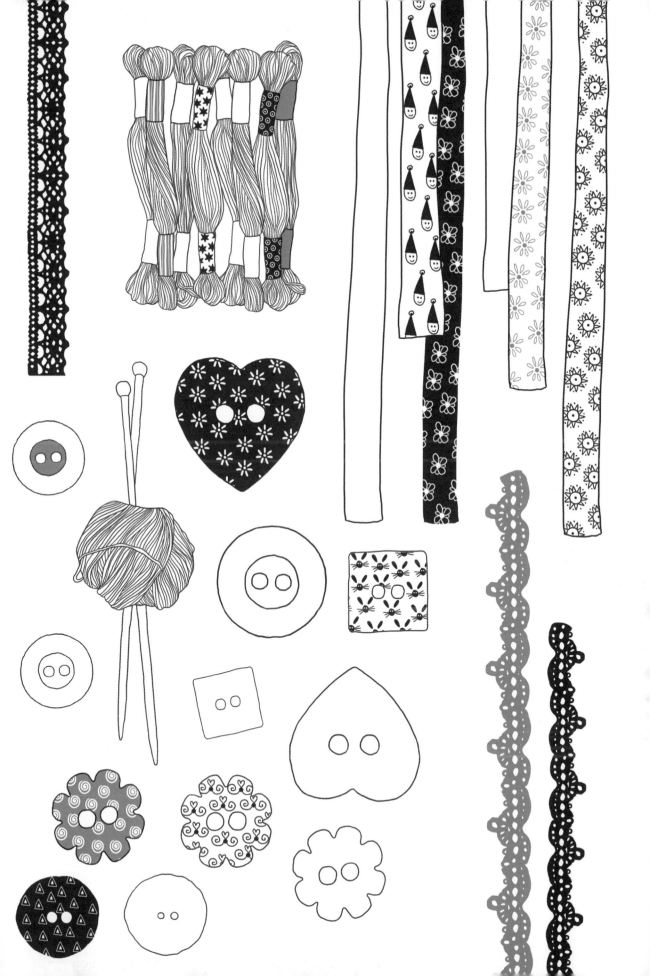

Design your own
washi-tape

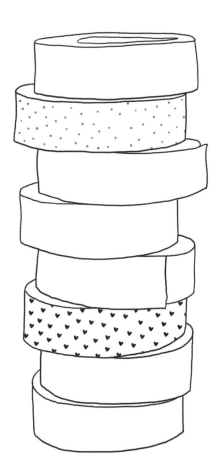

Draw the CHARMING face
and the EXTRAVAGANT hairstyle
of Madame de Pompadour

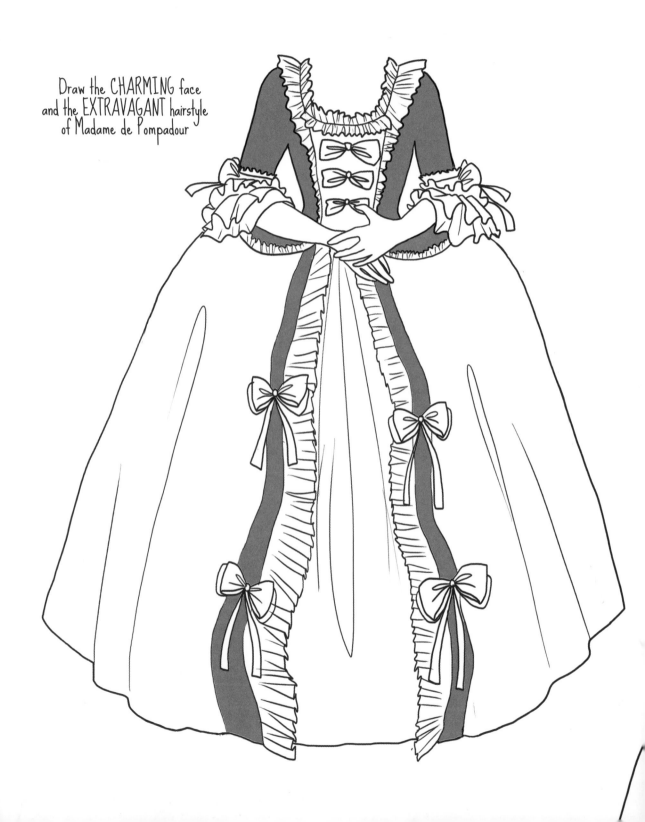

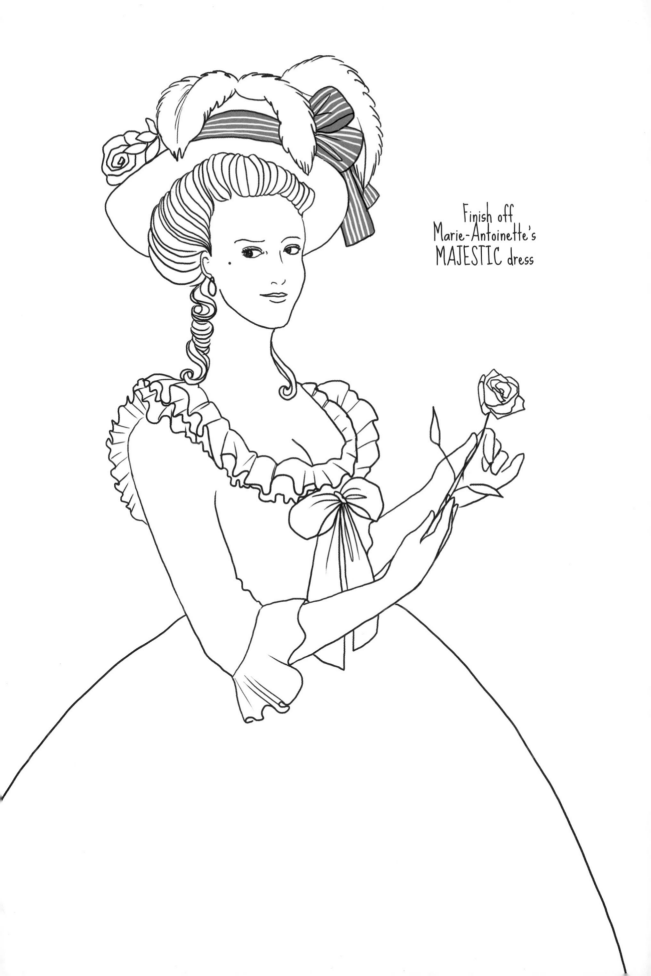

Finish off
Marie-Antoinette's
MAJESTIC dress

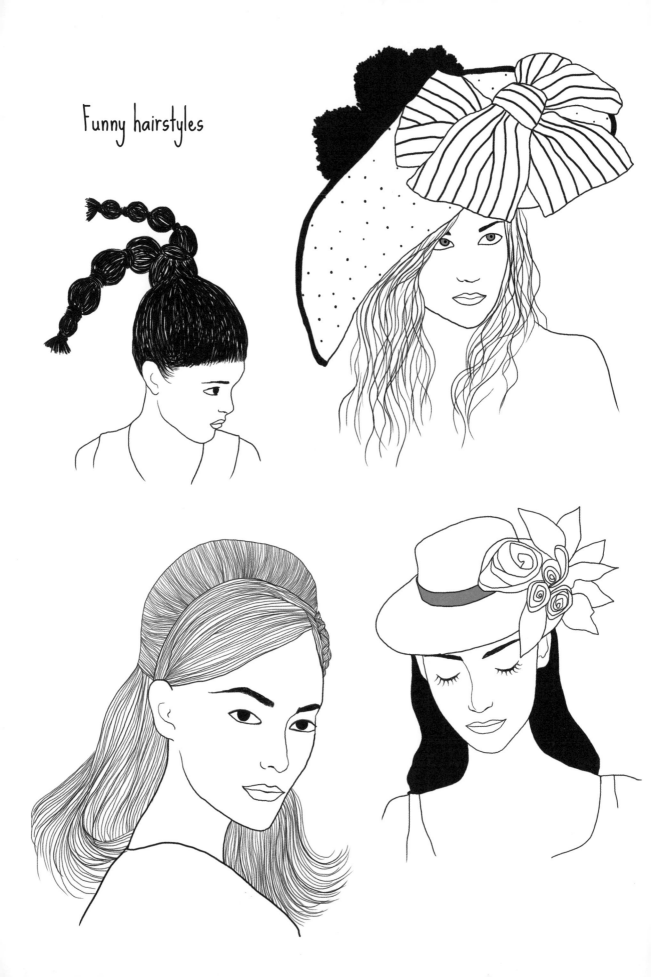

Funny hairstyles

Your turn to draw
a funny face

Draw your PATTERN

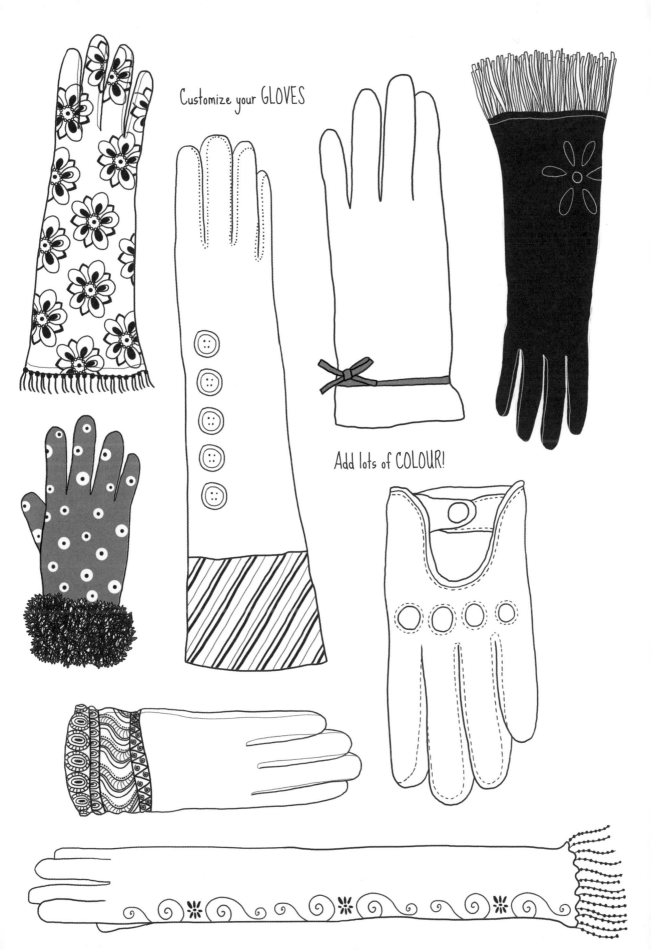

Customize your GLOVES

Add lots of COLOUR!

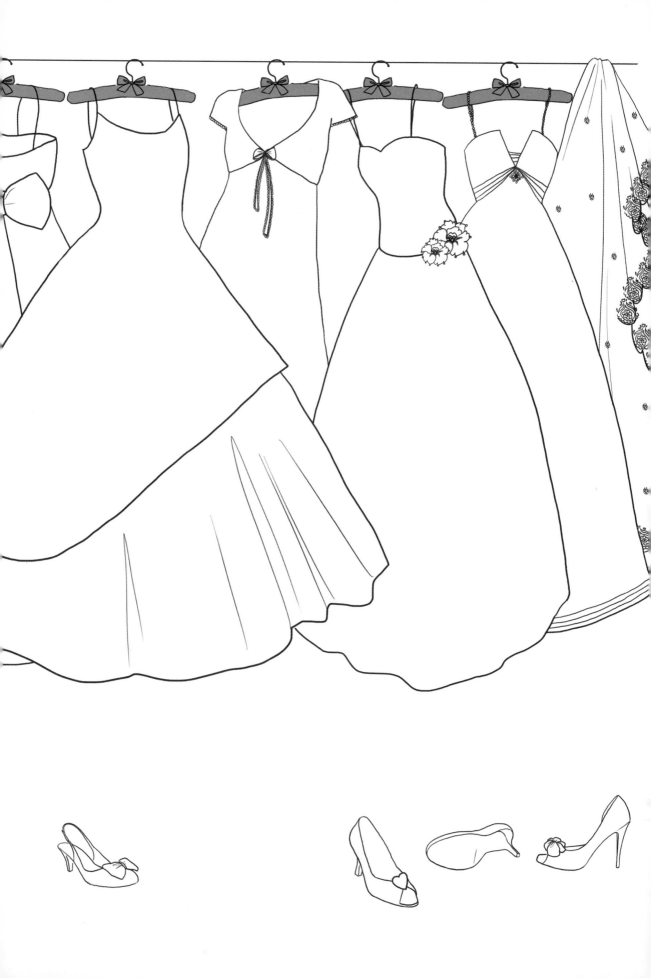

Design the most extravagant wedding dress of your wildest dreams!

Give them even more happiness by completing
the outfits of these newlyweds

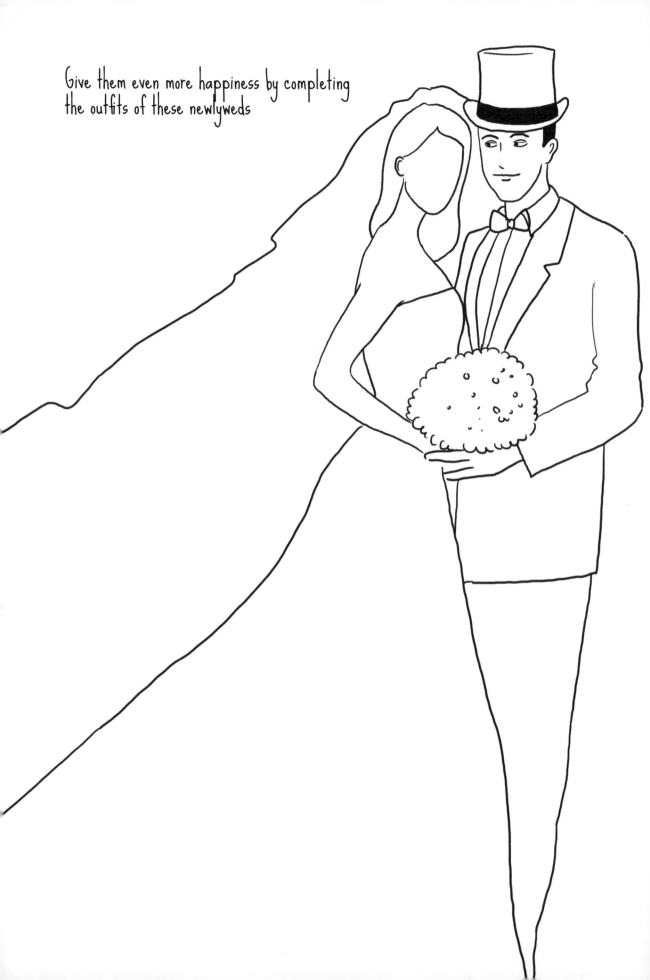

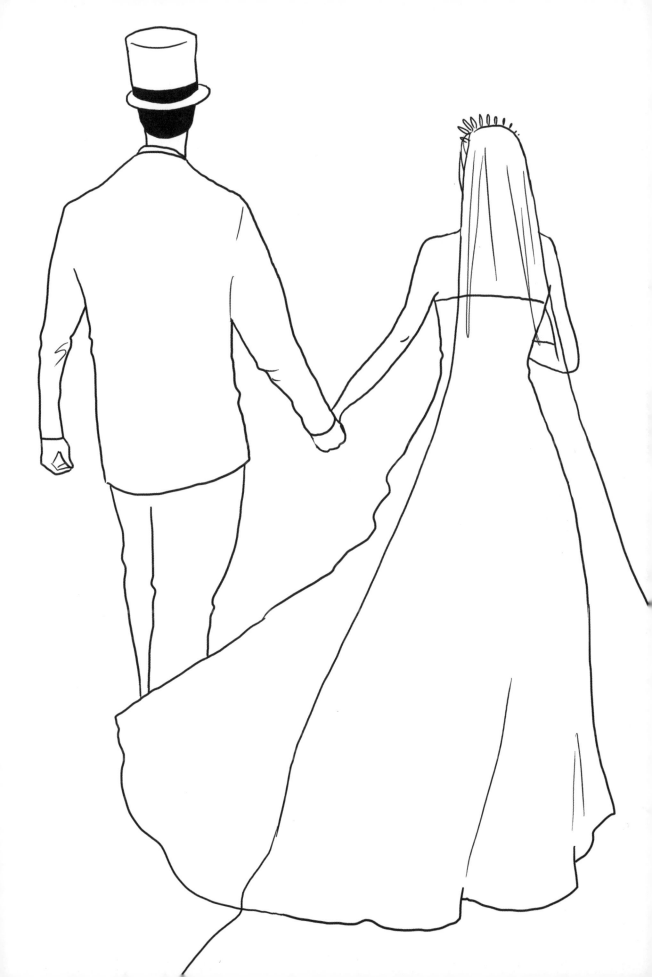

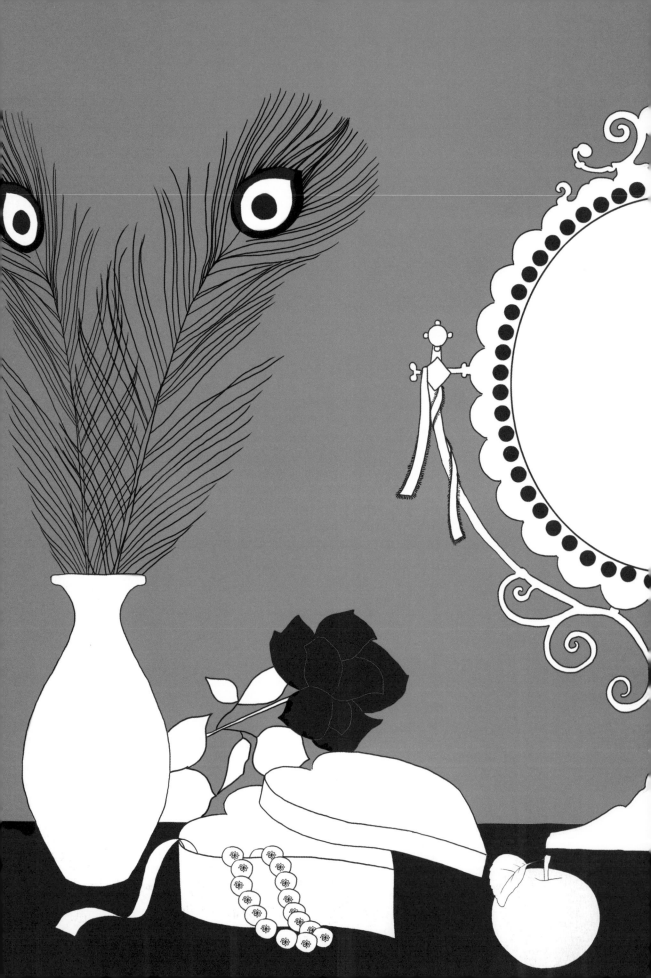

The mirror has two faces

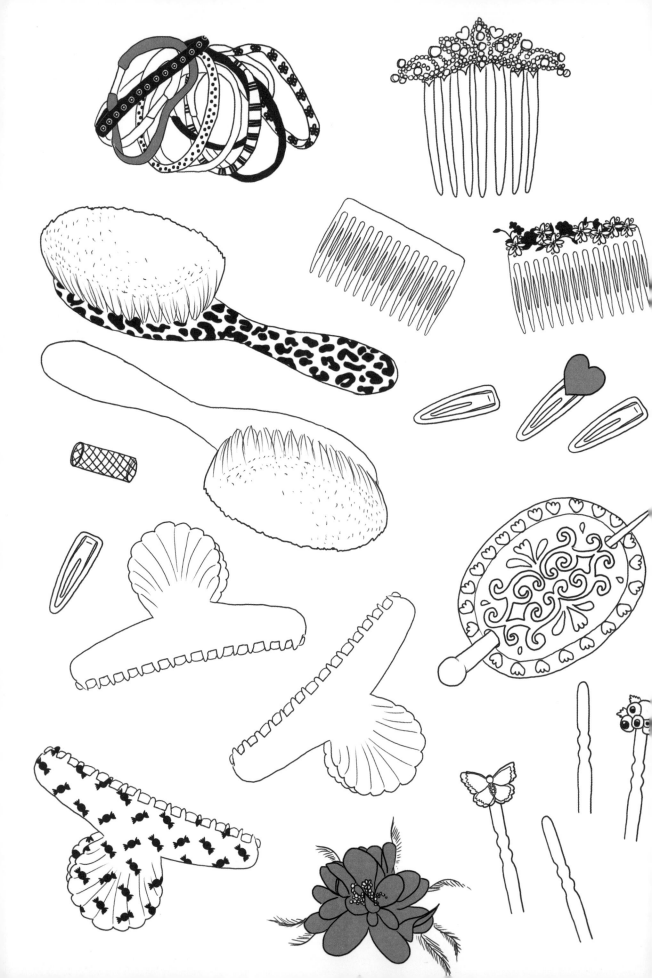

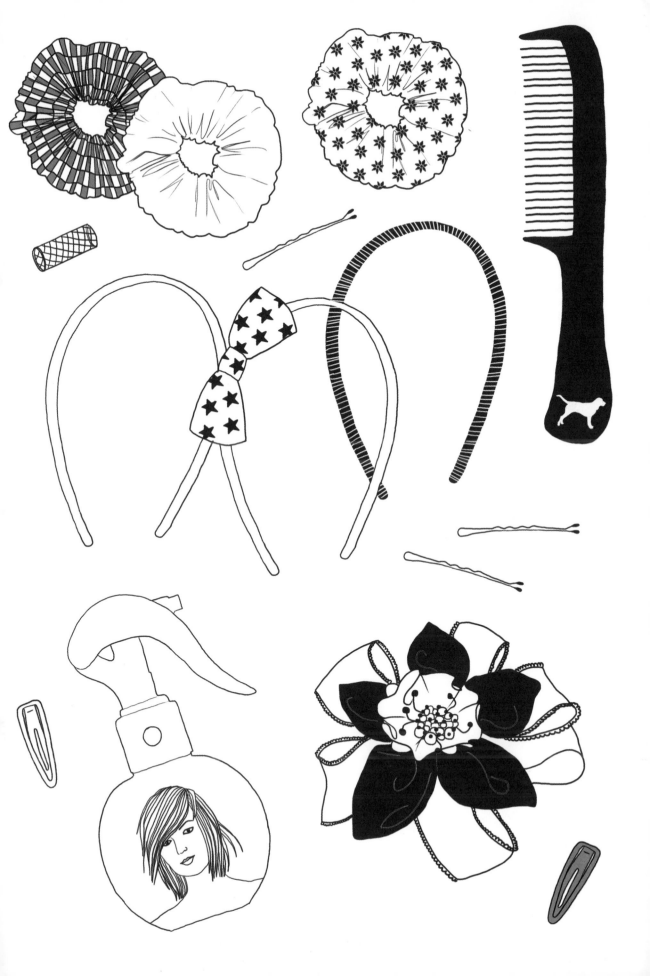

Create an
INCREDIBLE
hairstyle

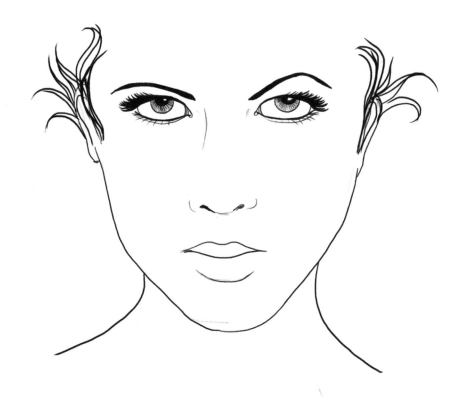

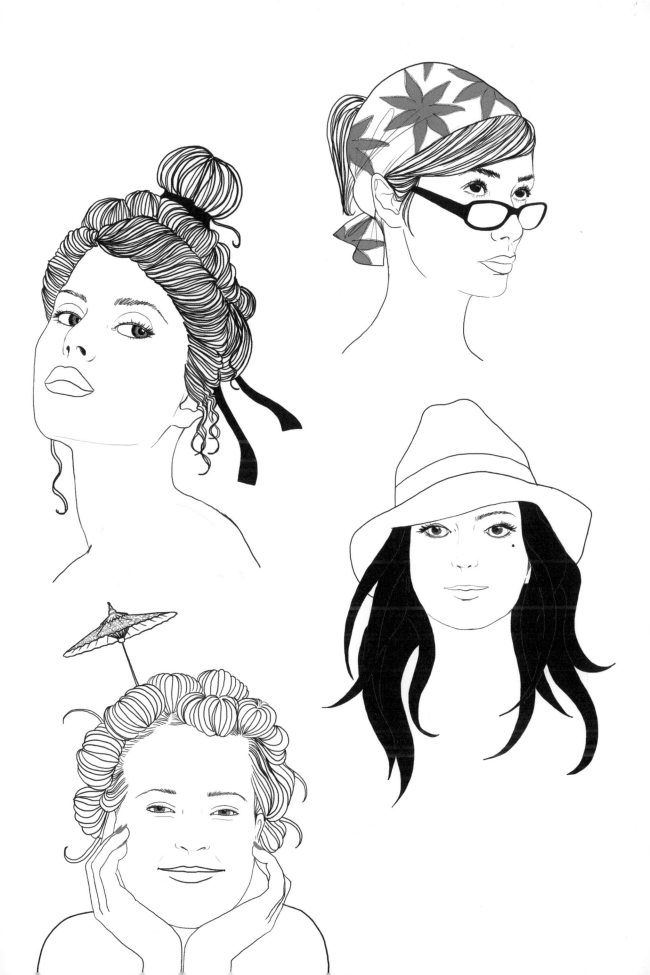

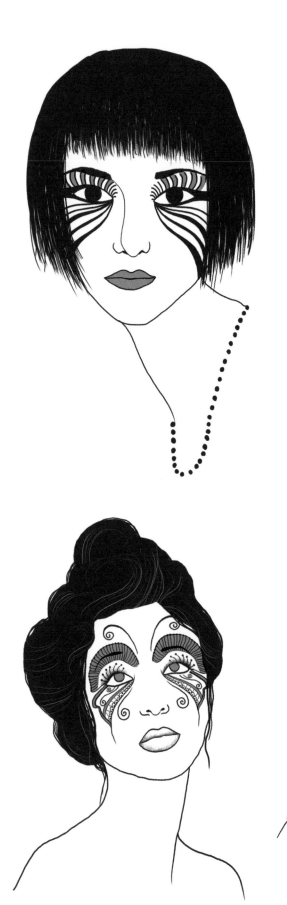

Go wild with make-up!

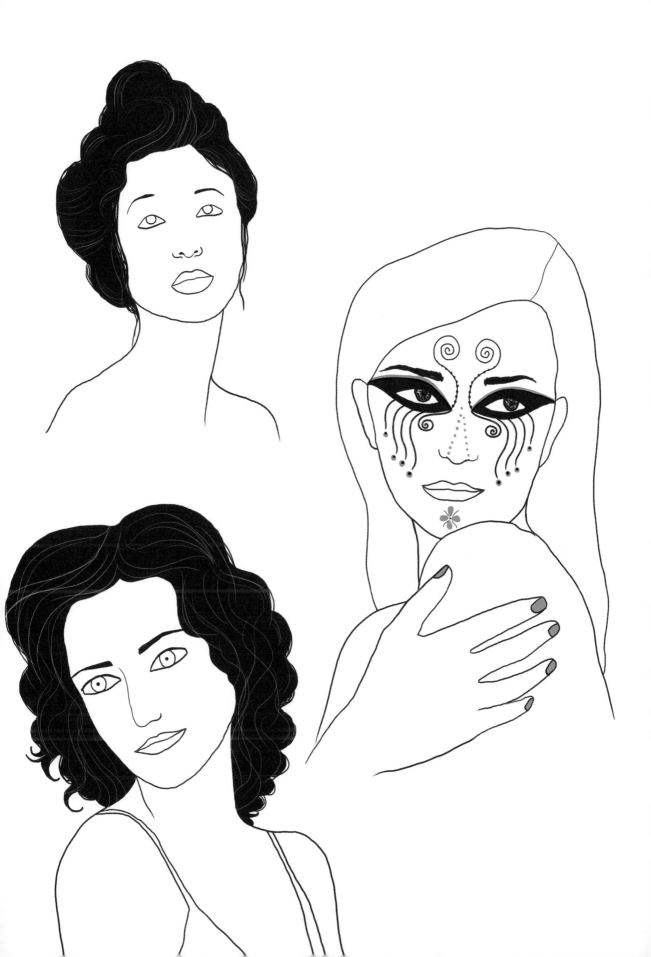

Design a tiara

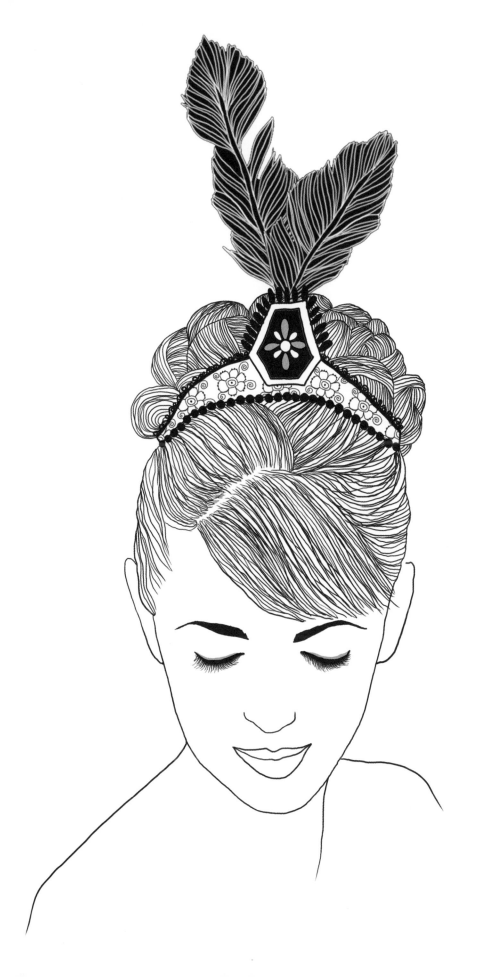

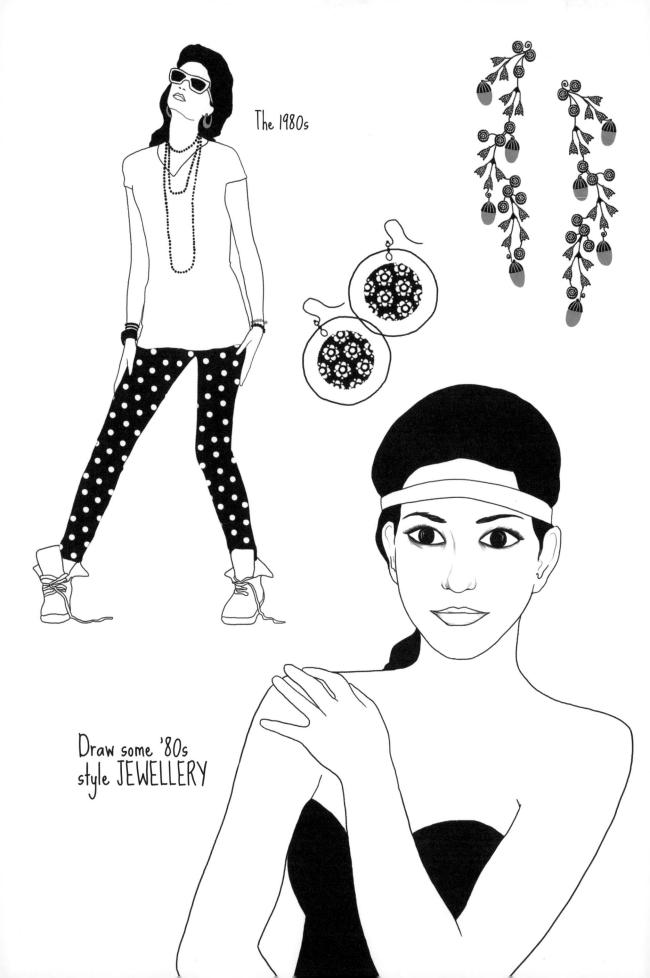

The 1980s

Draw some '80s
style JEWELLERY

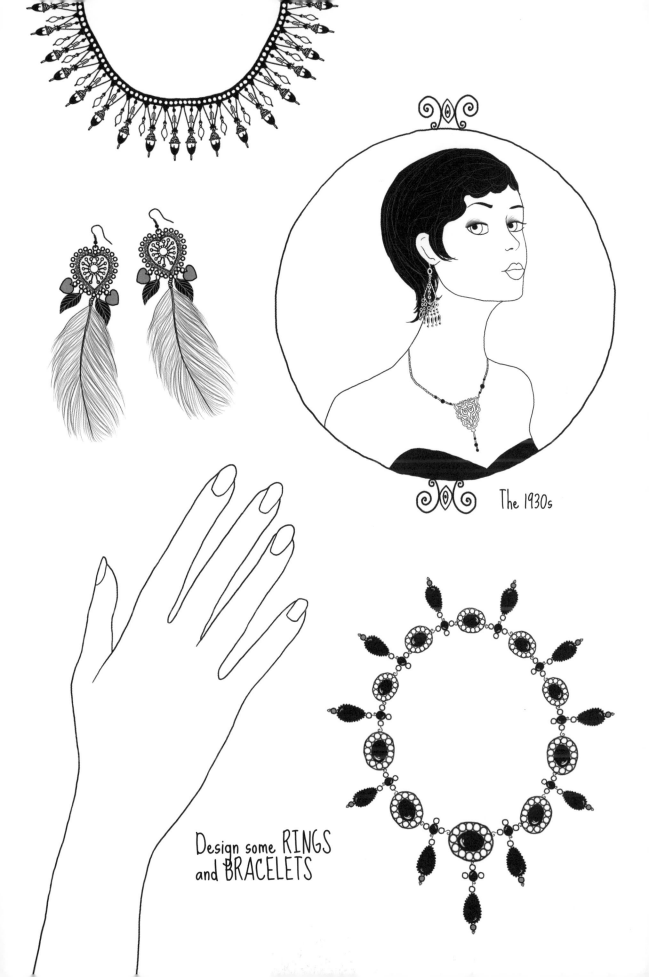

The 1930s

Design some RINGS
and BRACELETS

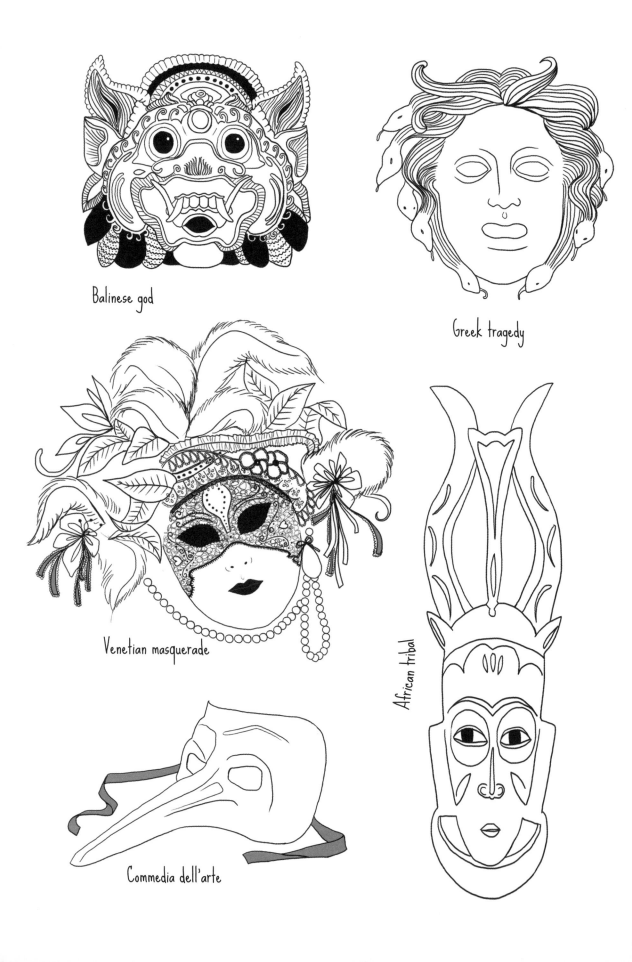

Balinese god

Greek tragedy

Venetian masquerade

African tribal

Commedia dell'arte

Cut out and create your own masks

taking inspiration from the following page

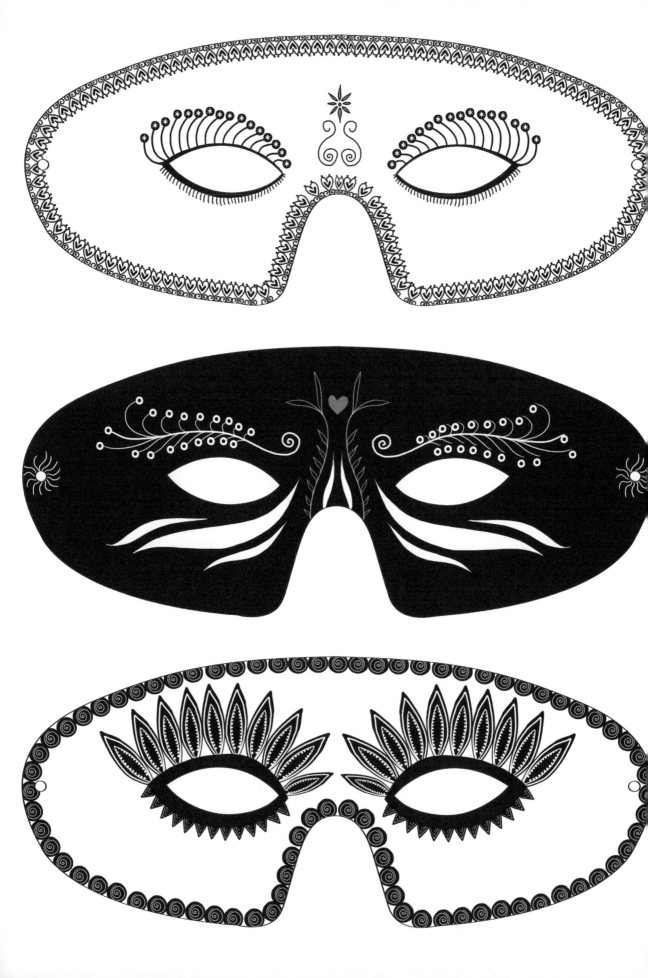

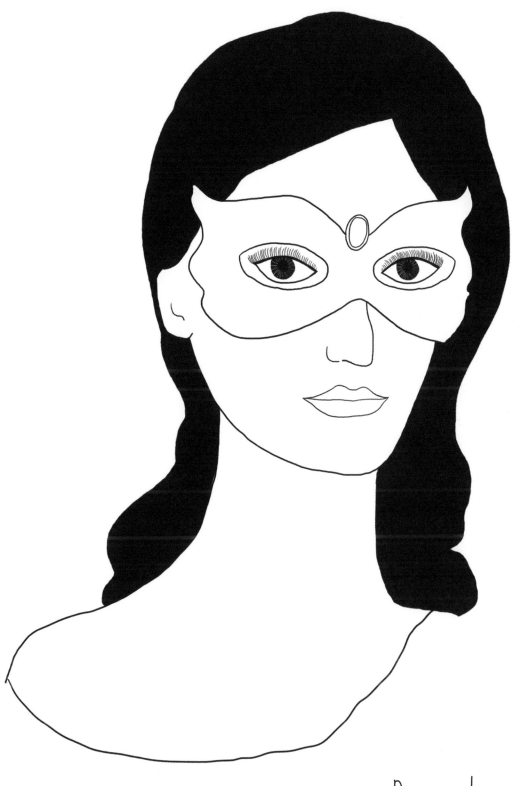

Design a mask
for a MAGICAL evening

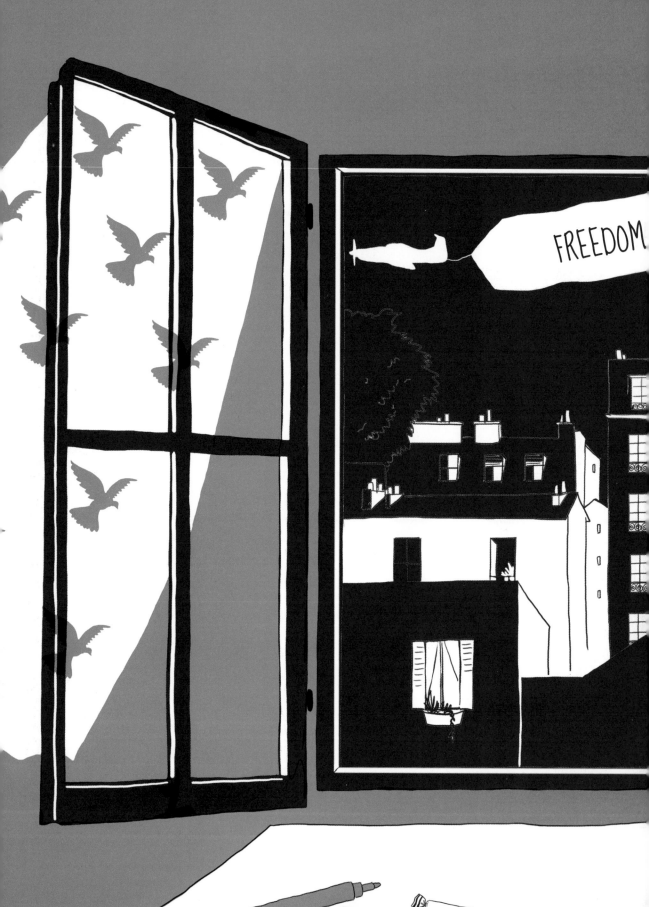

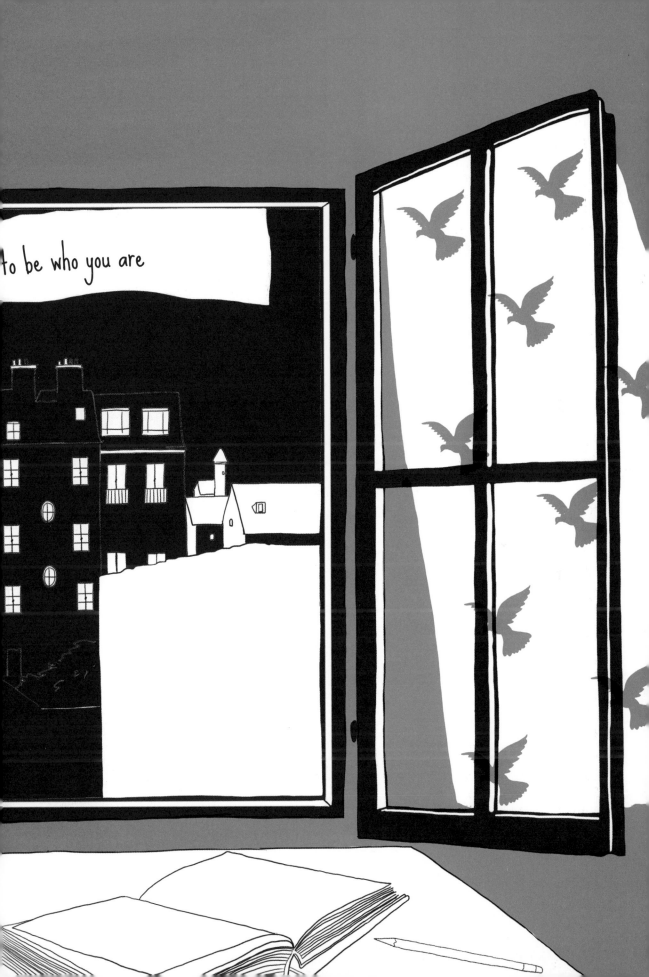

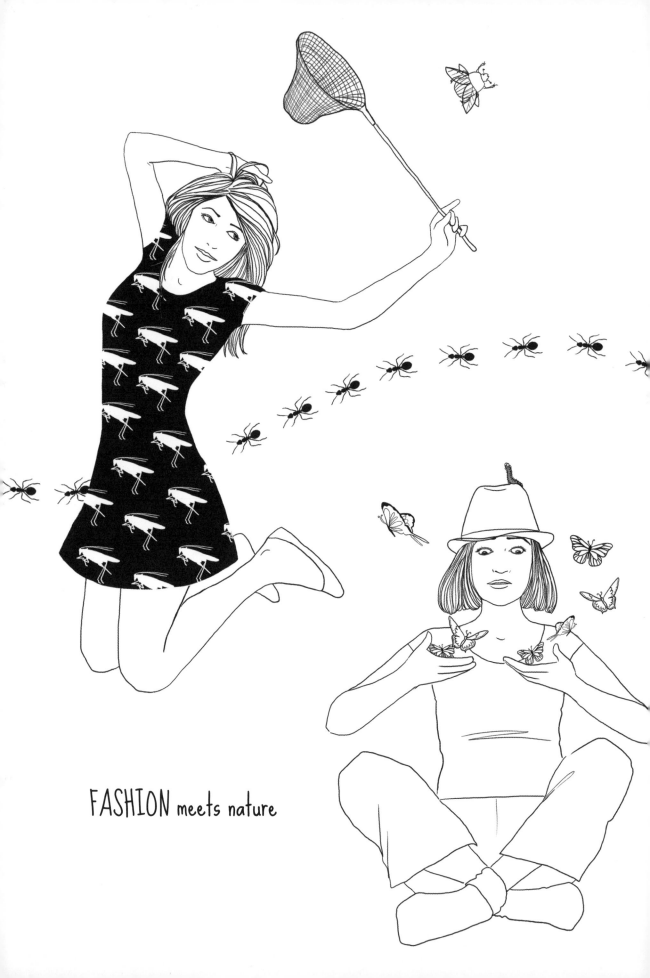

FASHION meets nature

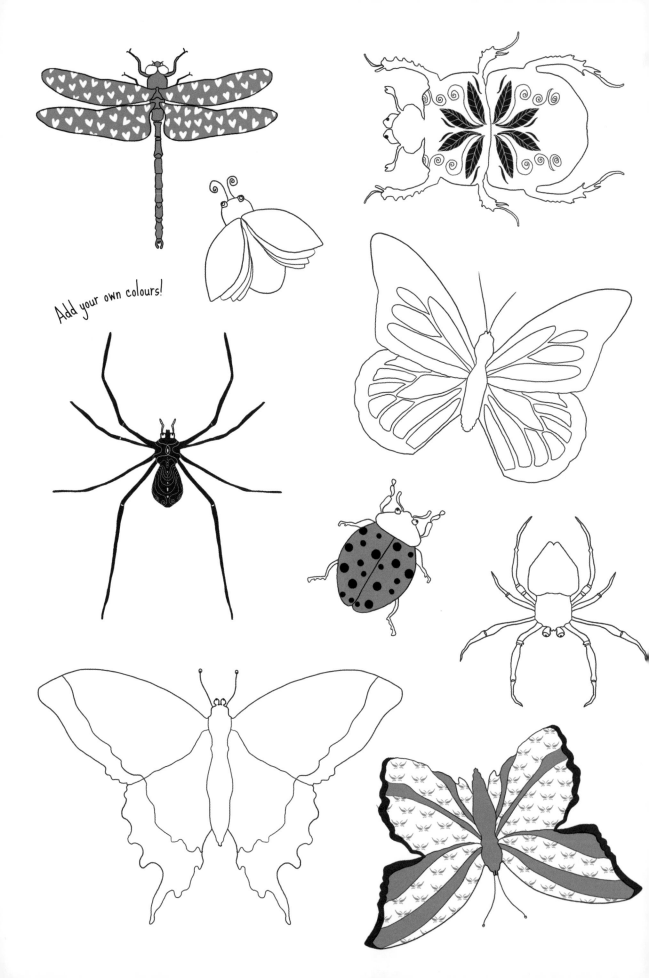

Add your own colours!

Add your own patterns!

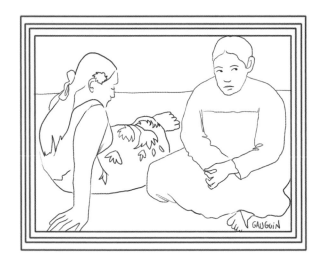

GAUGUIN

Get under the skin of the world's
most FAMOUS artists

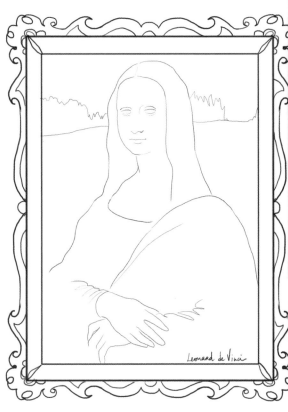

Leonard de Vinci

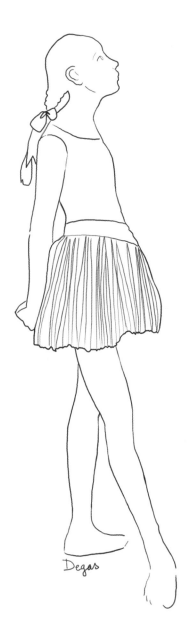

Degas

Vermeer

Manet

Modigliani

PICASSO

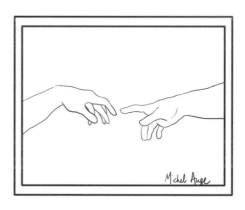

Michel Ange

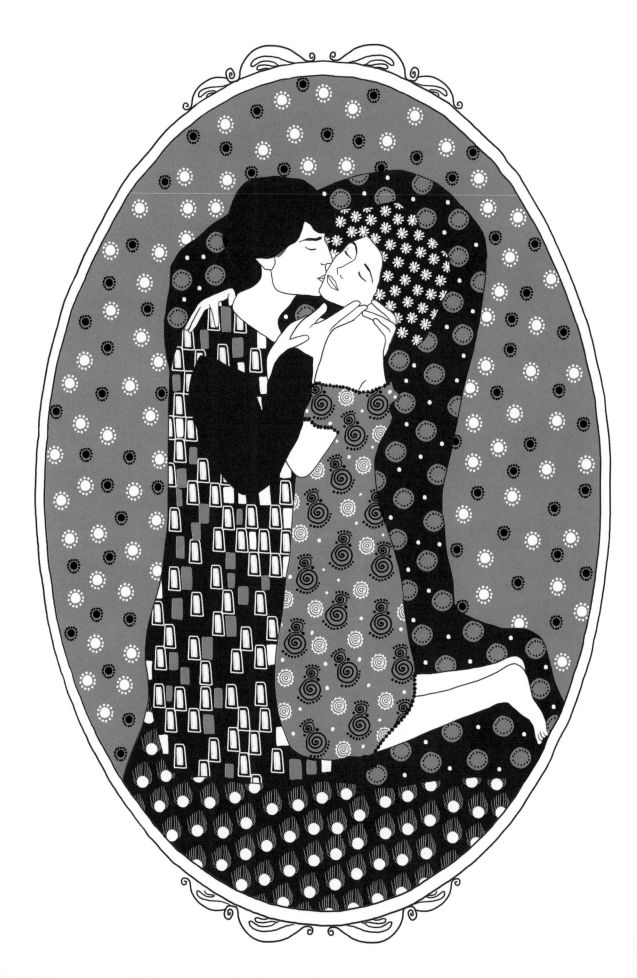

Be inspired by a great painter to create your own WORK of ART

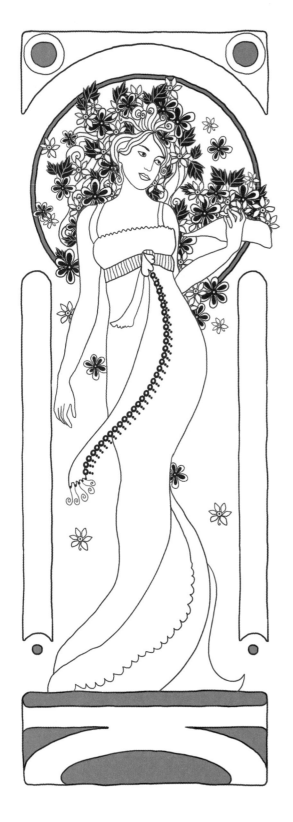

BEAUTIFUL
Art Nouveau

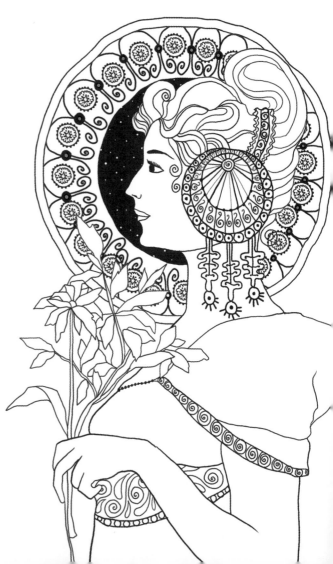

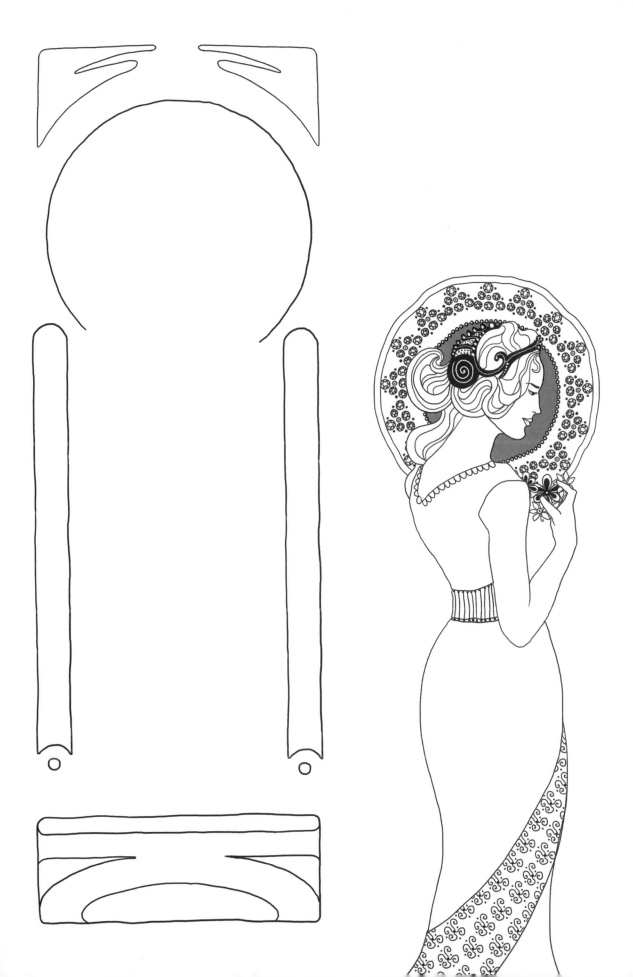

«Everything we see hides another thing,
we always want to see what is hidden»

René Magritte

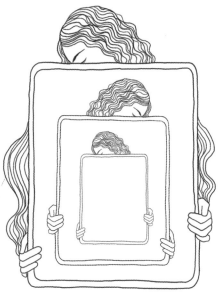

this is NOT a woman

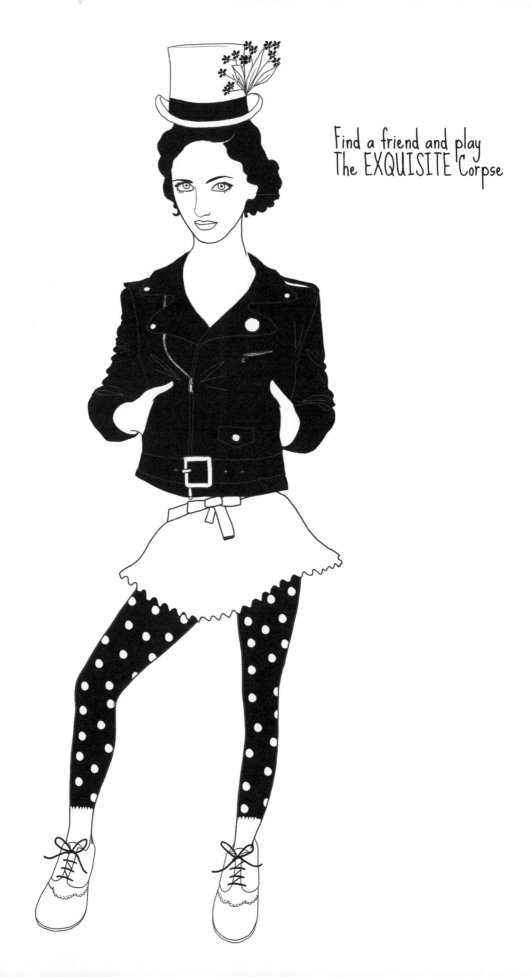

Find a friend and play
The EXQUISITE Corpse

Draw the hat,
fold on the dotted line
and pass to your friend

same with the head

same with the torso

same with the legs

Finally draw the shoes
then UNFOLD it all!

Use this page for another
Exquisite Corpse!

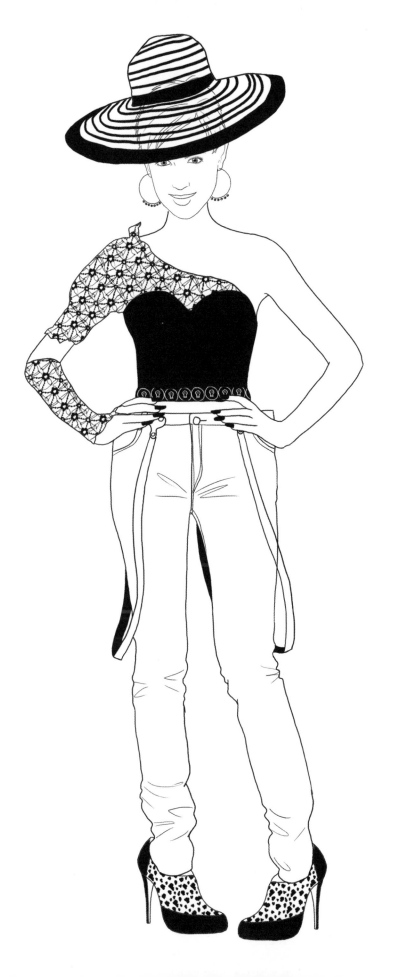

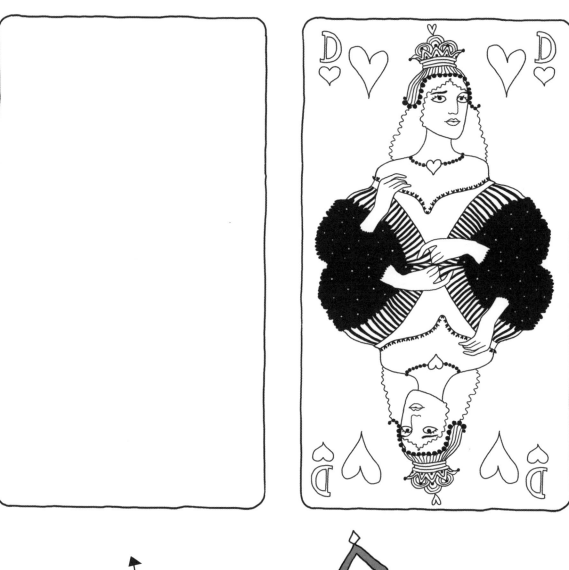

personalize
your cards

between

King
and
Queen

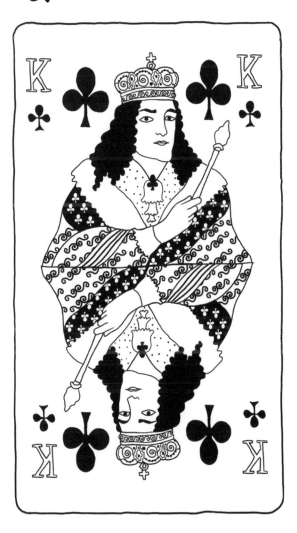

Put some funky
glasses on her

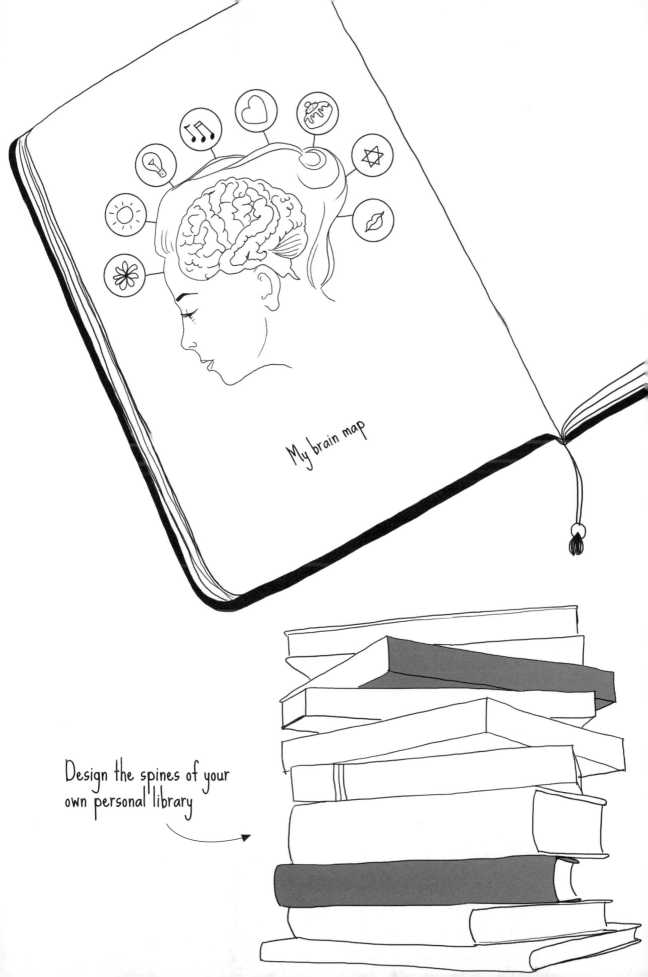

My brain map

Design the spines of your
own personal library

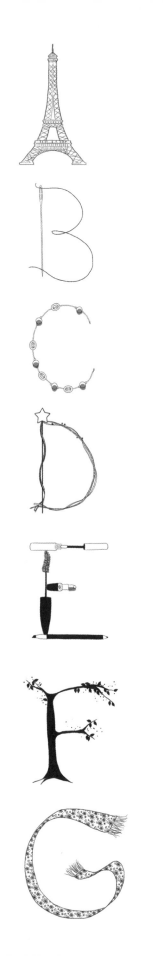

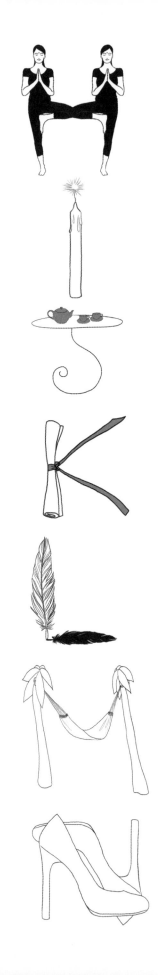

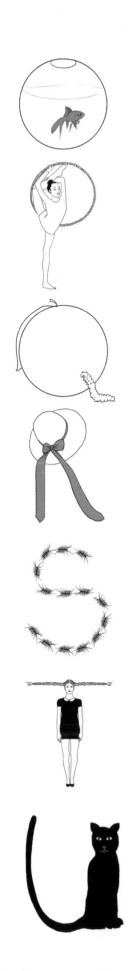

CREATE your
own typefaces

PARIS RASTA

LEA Metro

NEW-YORK

NEW-YORK

Jane BUILDING

ALICE

LoVe

write YOUR NAME on YOUR DOOR

make some BADGES to
cut out and keep!

make some BADGES to
cut out and keep!

Continue the pattern to INFINITY

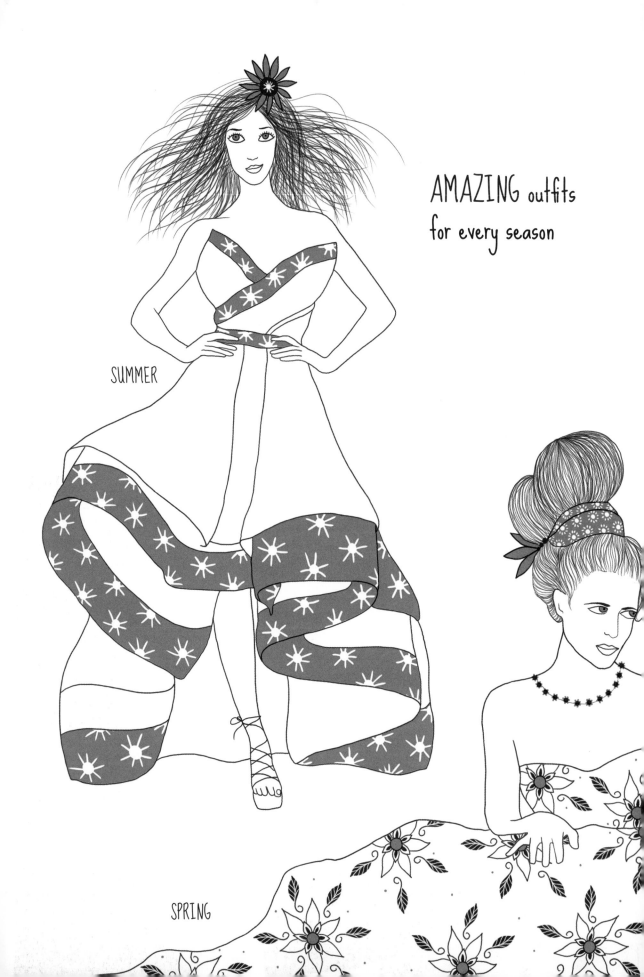

AMAZING outfits
for every season

SUMMER

SPRING

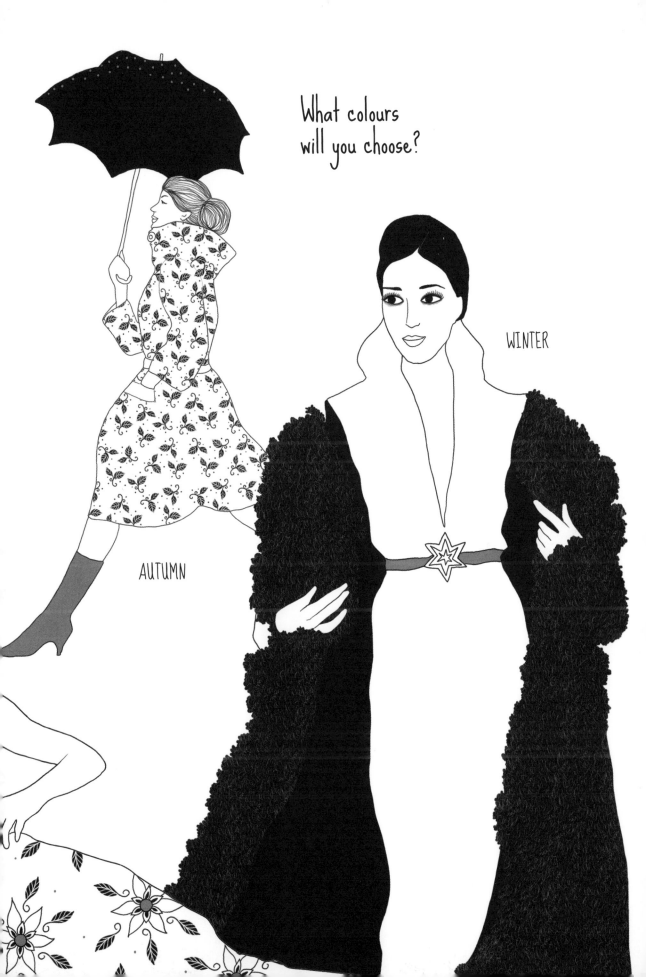

What colours
will you choose?

WINTER

AUTUMN

 Design your own seasonal fashion collection!

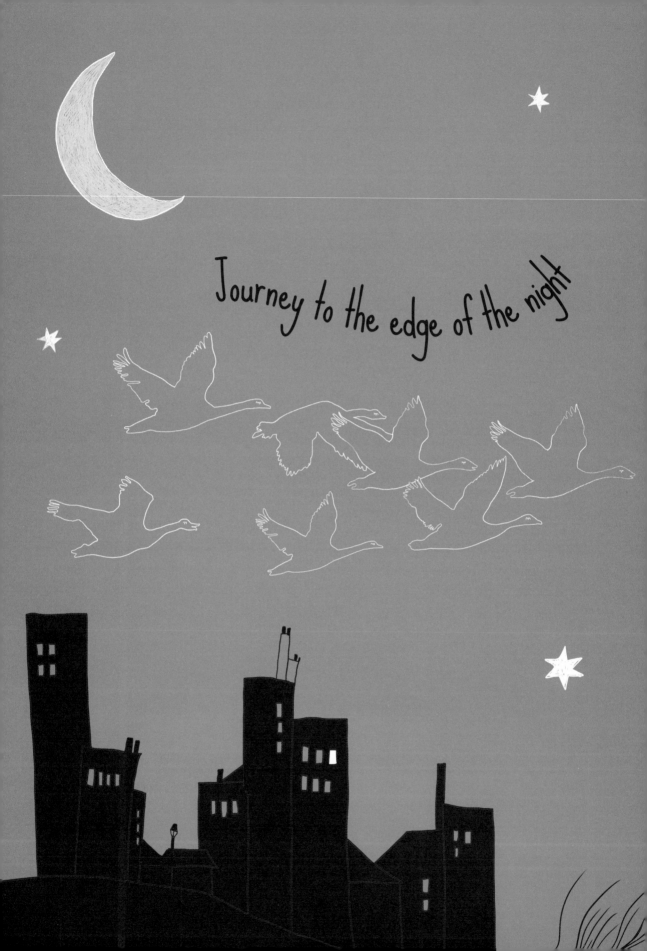

Journey to the edge of the night

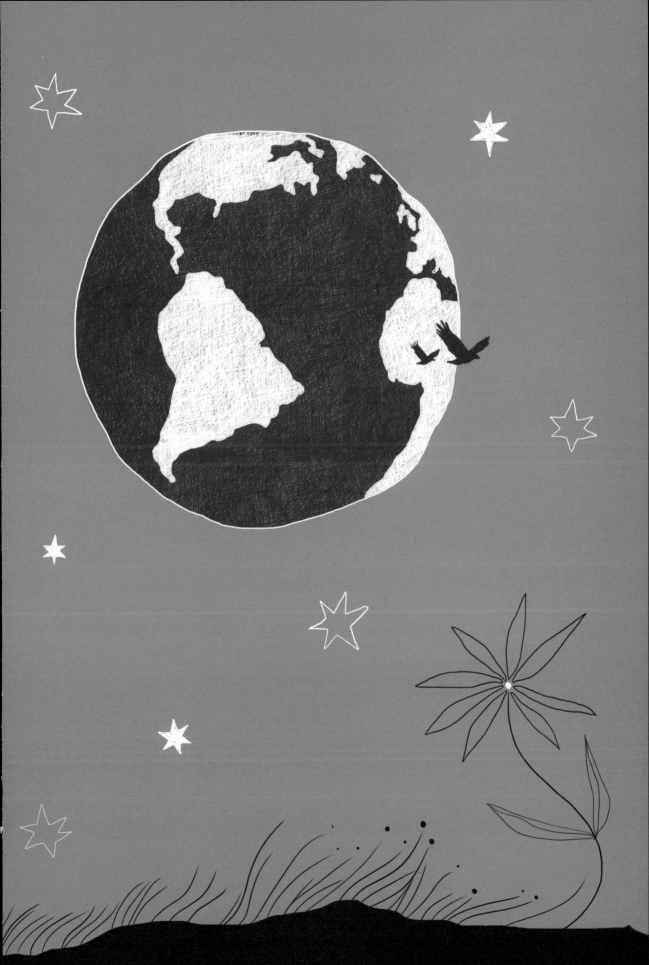

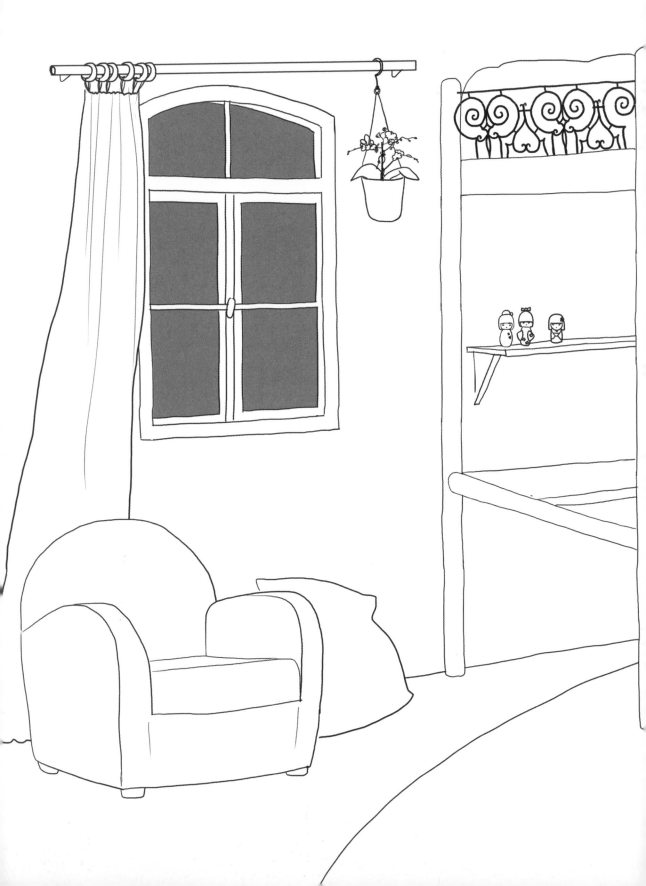

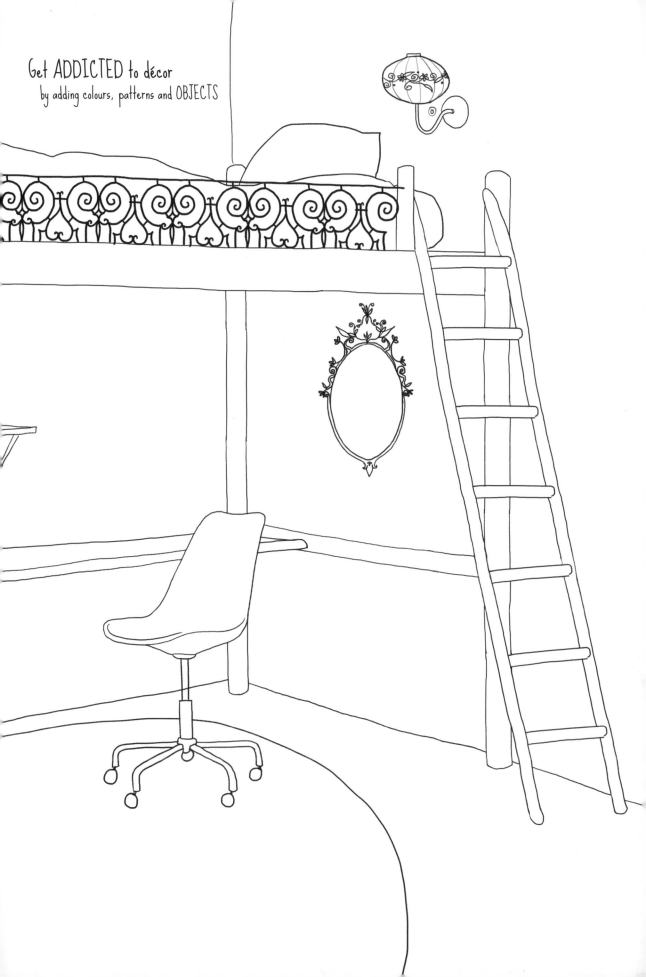

Get ADDICTED to décor
by adding colours, patterns and OBJECTS

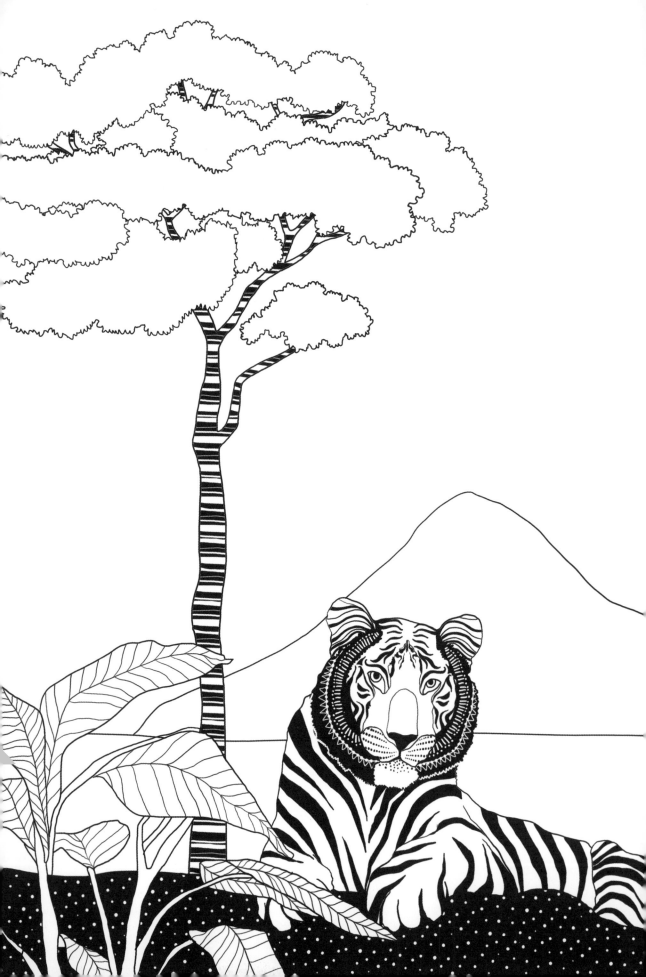

Fruits and vegetables from around the WORLD ...
Complete this unexpected landscape
and colour, colour, COLOUR!

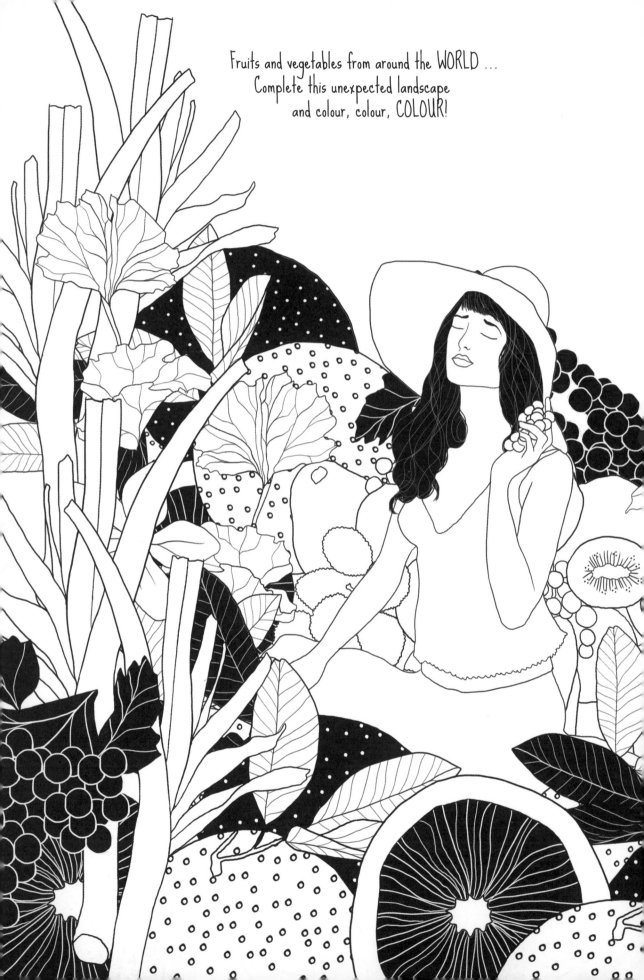

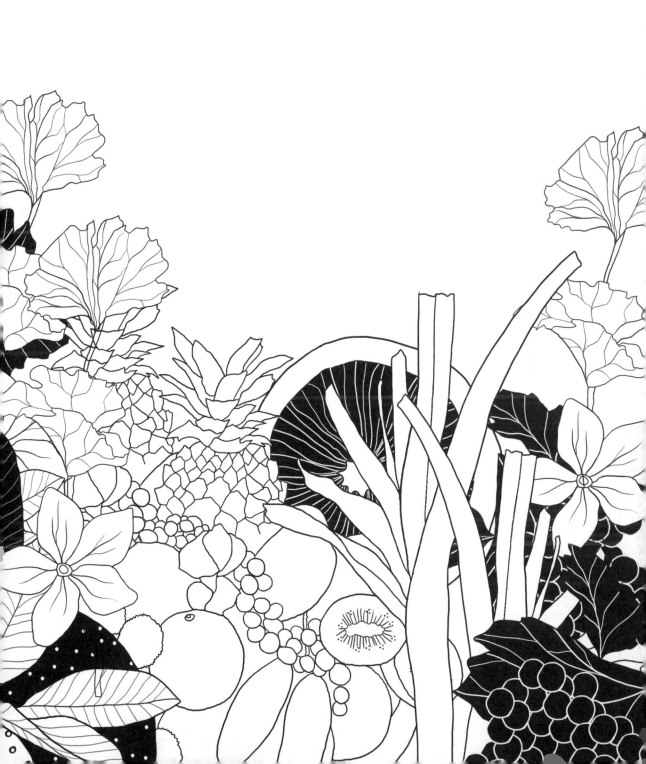

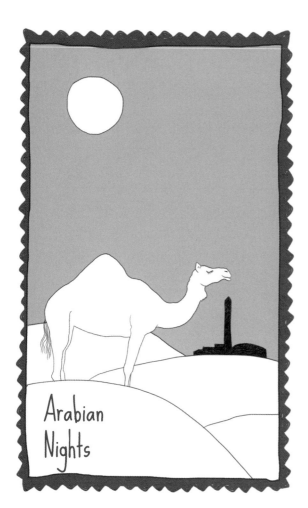

Arabian
Nights

My next destinations

...

...

...

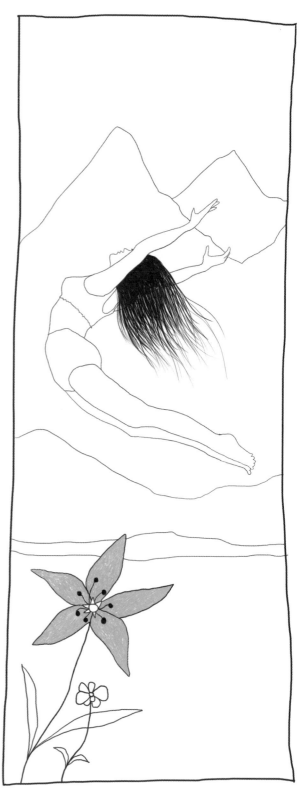

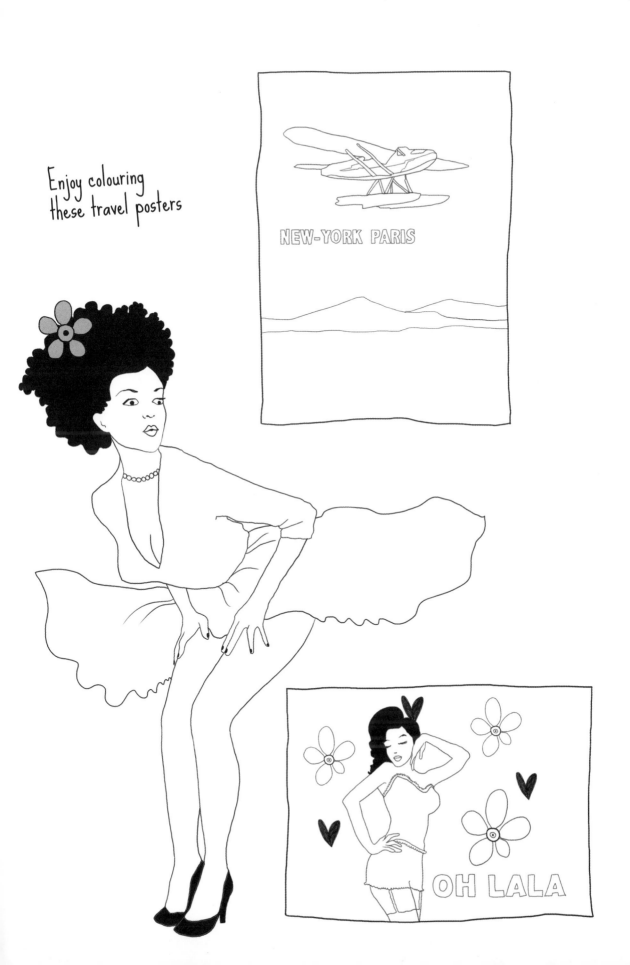

Enjoy colouring
these travel posters

NEW-YORK PARIS

OH LALA

THE continents

Draw some national motifs for the countries you have visited

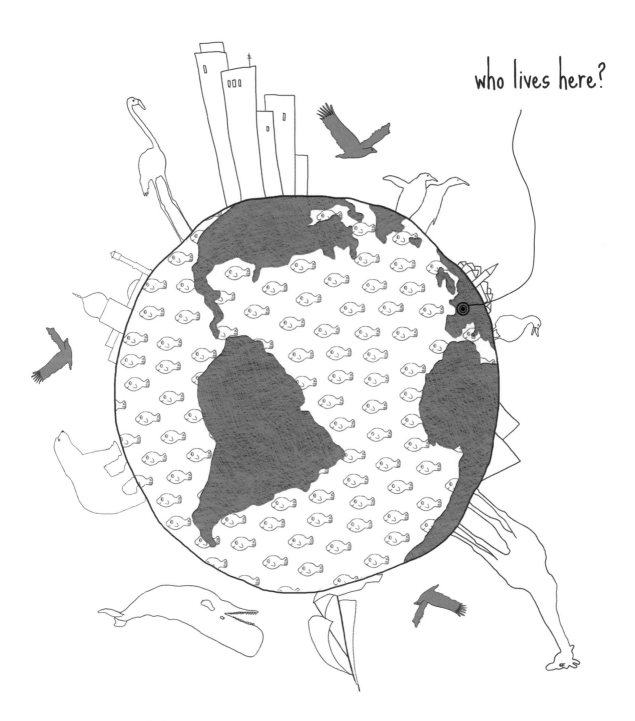

who lives here?

OUR planet

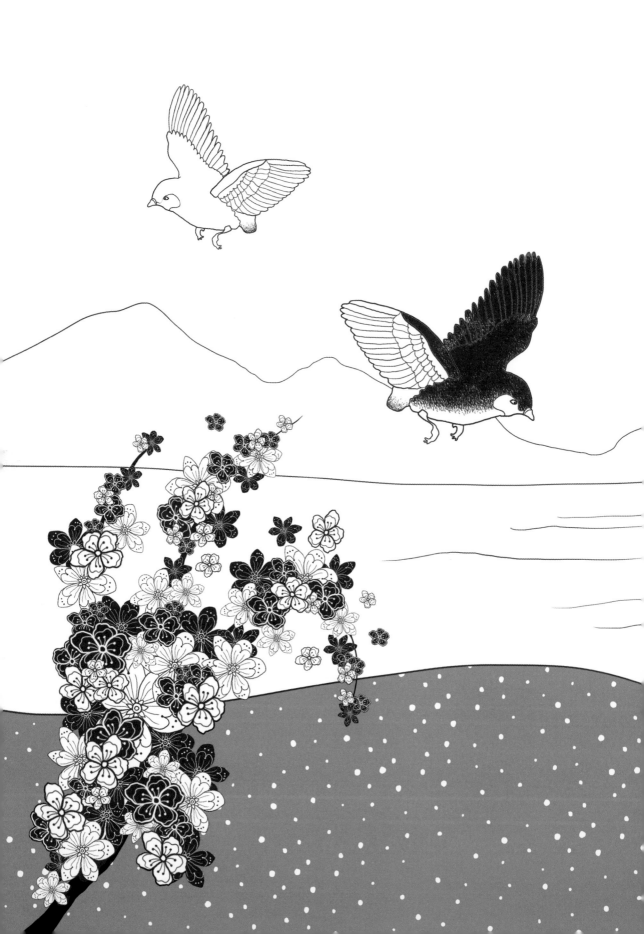

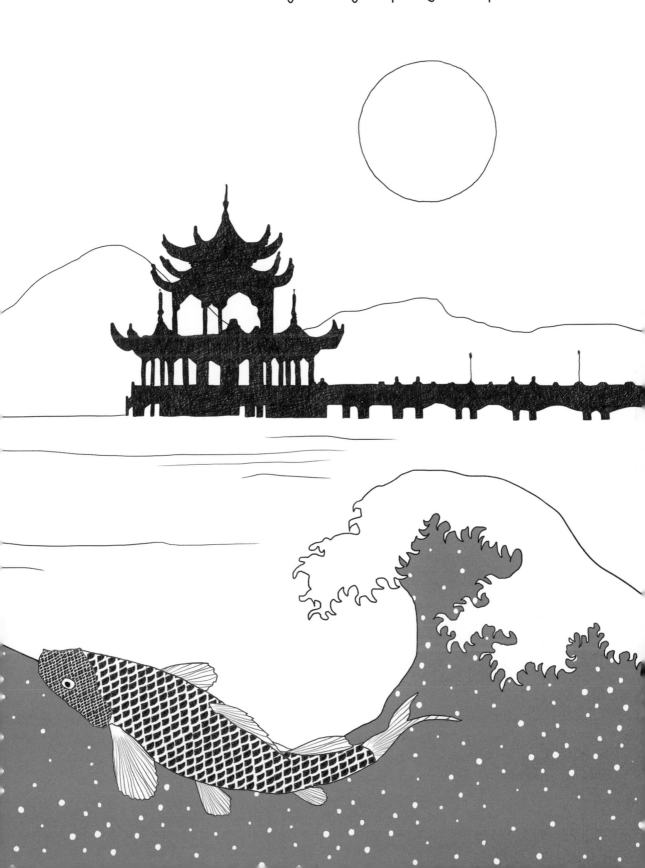
EXPRESS yourself by completing this Japanese scene

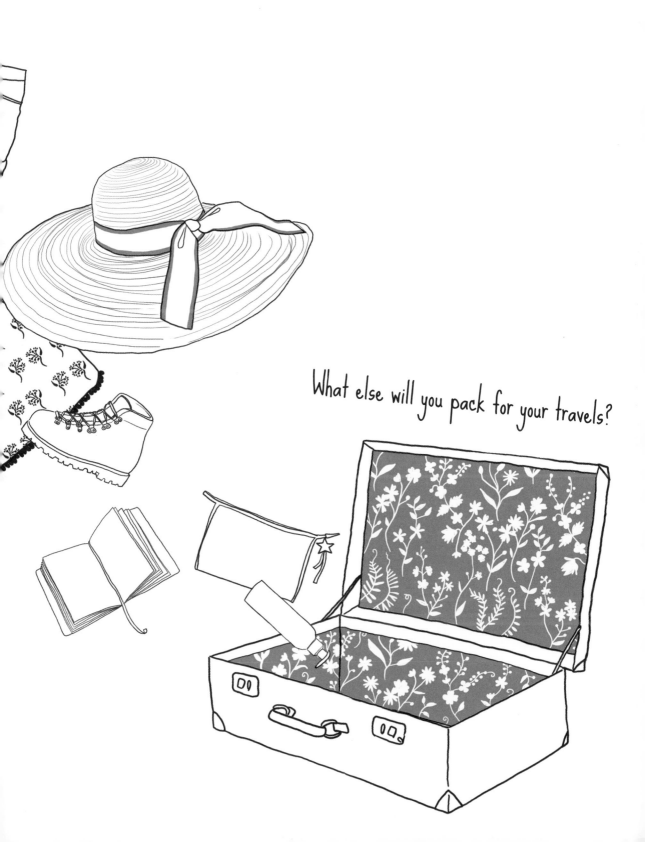

What else will you pack for your travels?

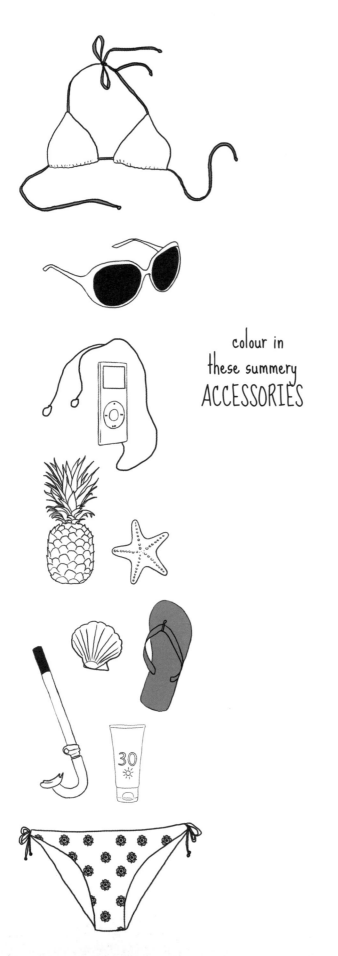

colour in
these summery
ACCESSORIES

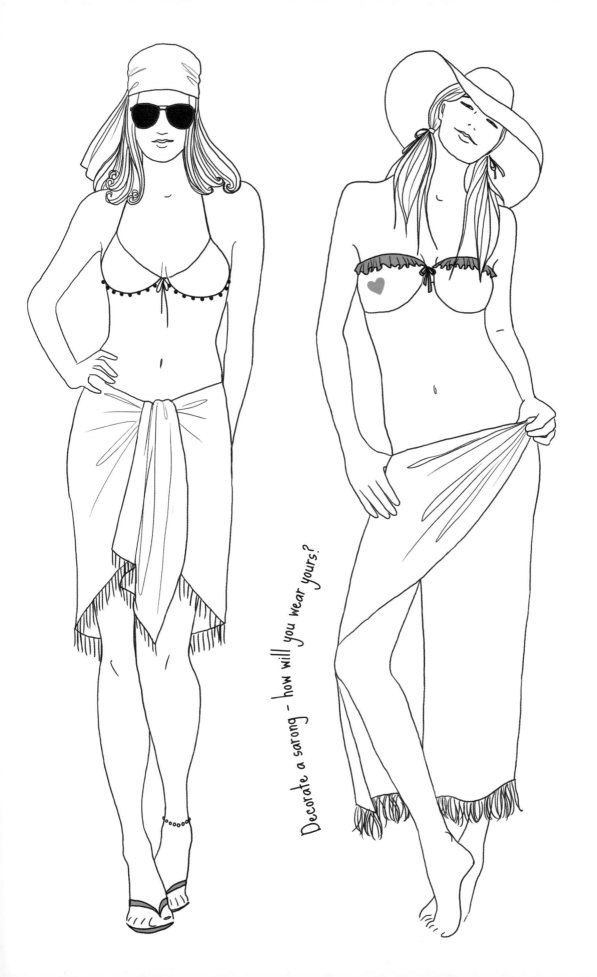

Decorate a sarong – how will you wear yours?

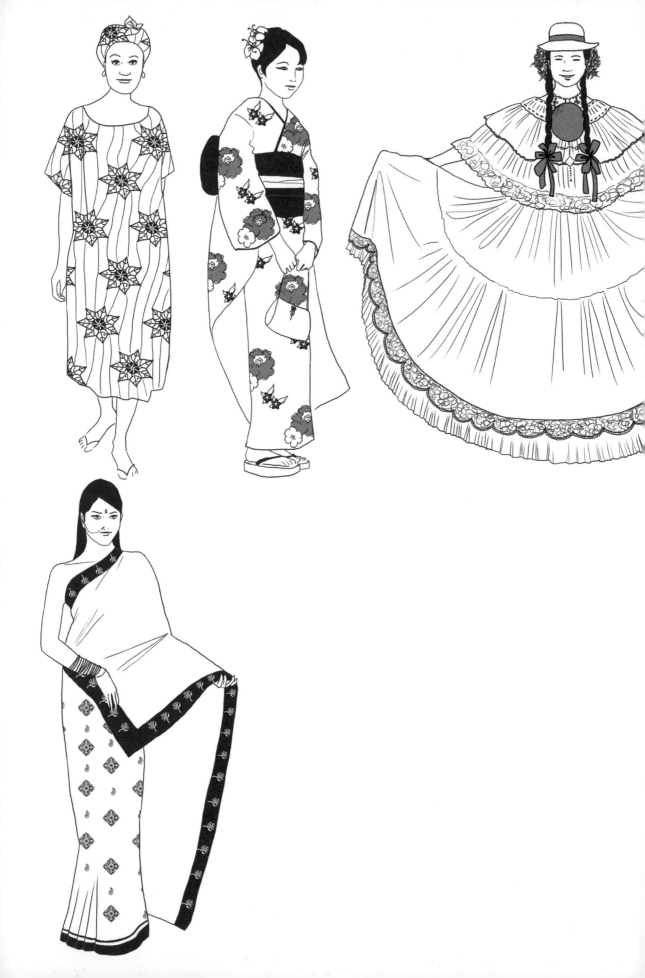

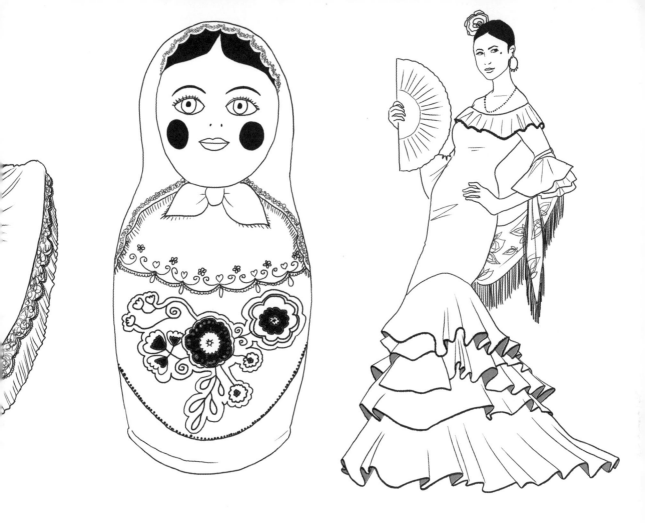

Travel the WORLD and continue your doll collection

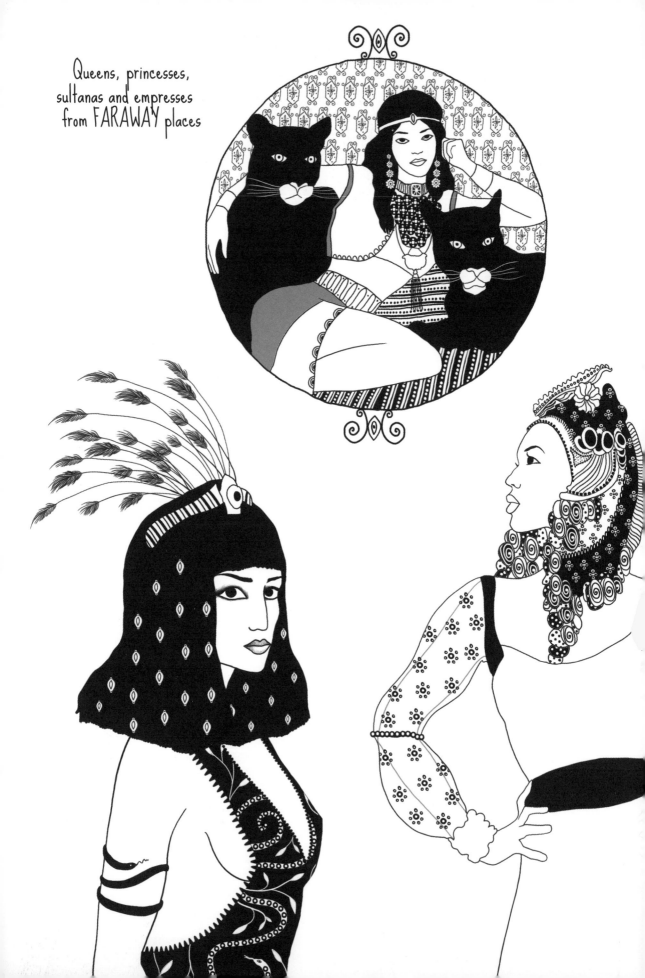

Queens, princesses, sultanas and empresses from FARAWAY places

Decorate the sultana

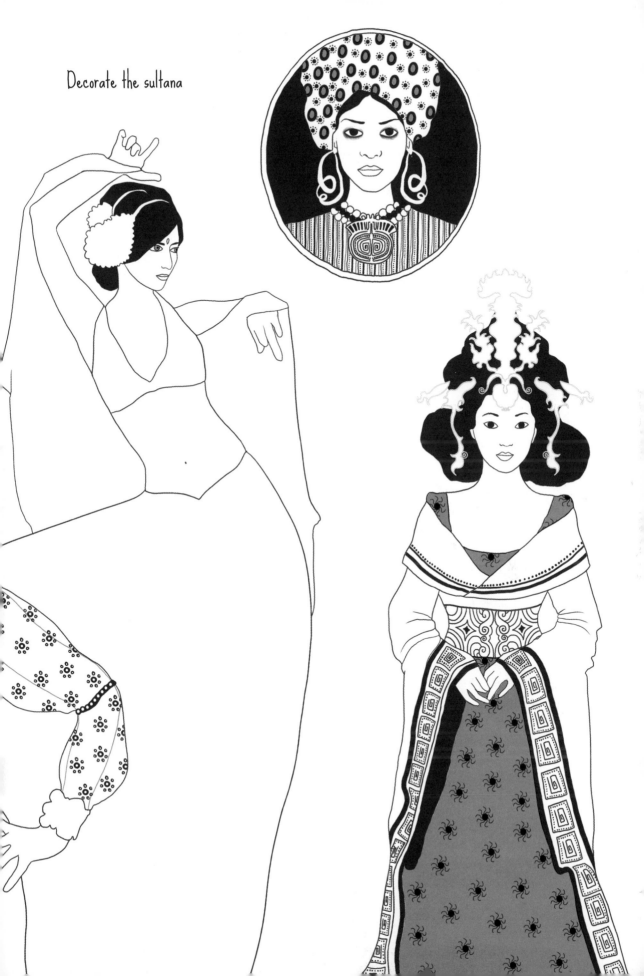

Wander the world and come back with all kinds of objects - colourful, tasty and spicy

1. Leave your imagination to infuse
2. Create other tea bags
3. Add patterns and colours

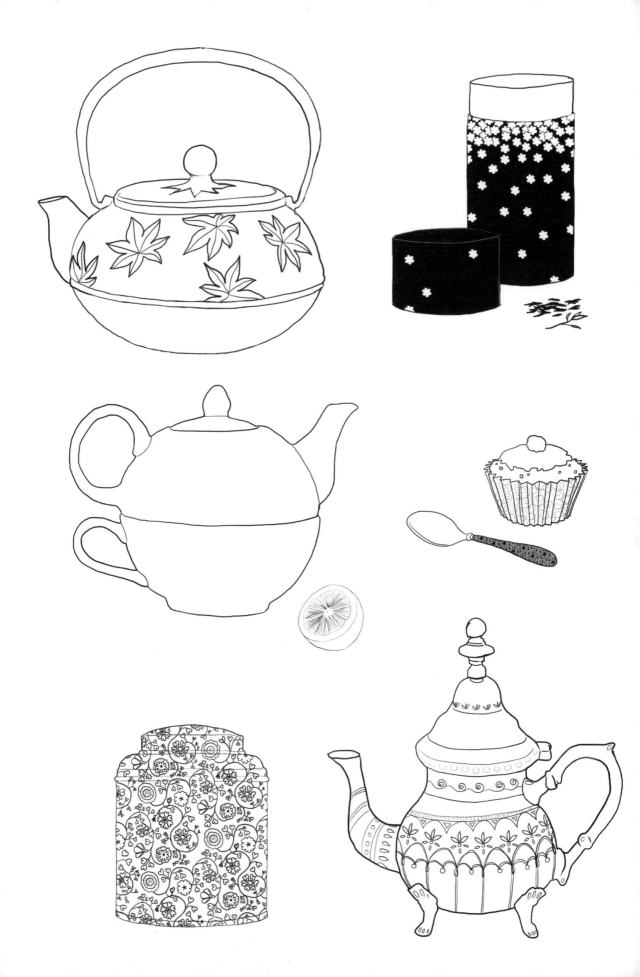

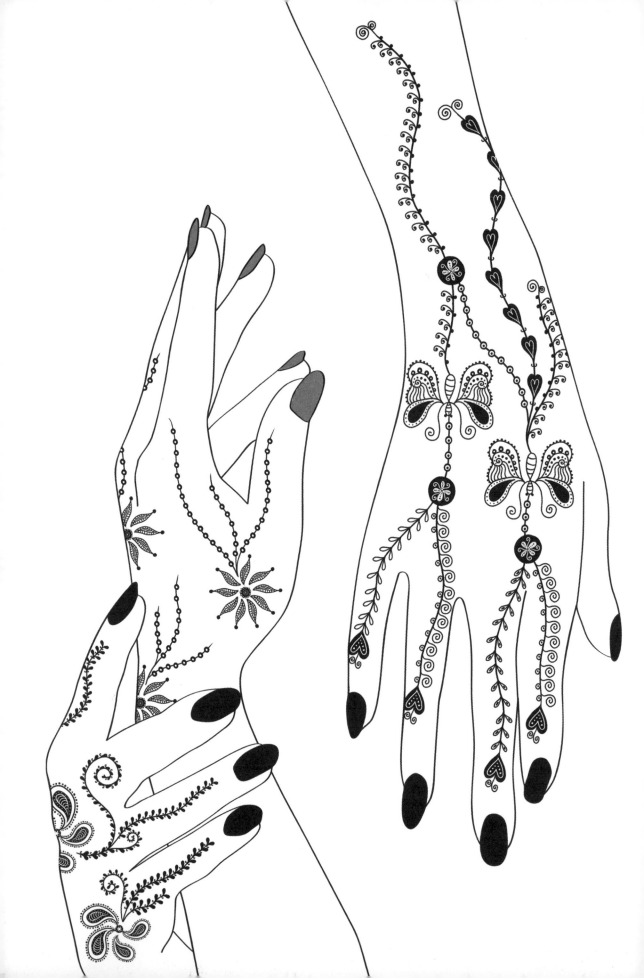

Create some henna
designs on these hands

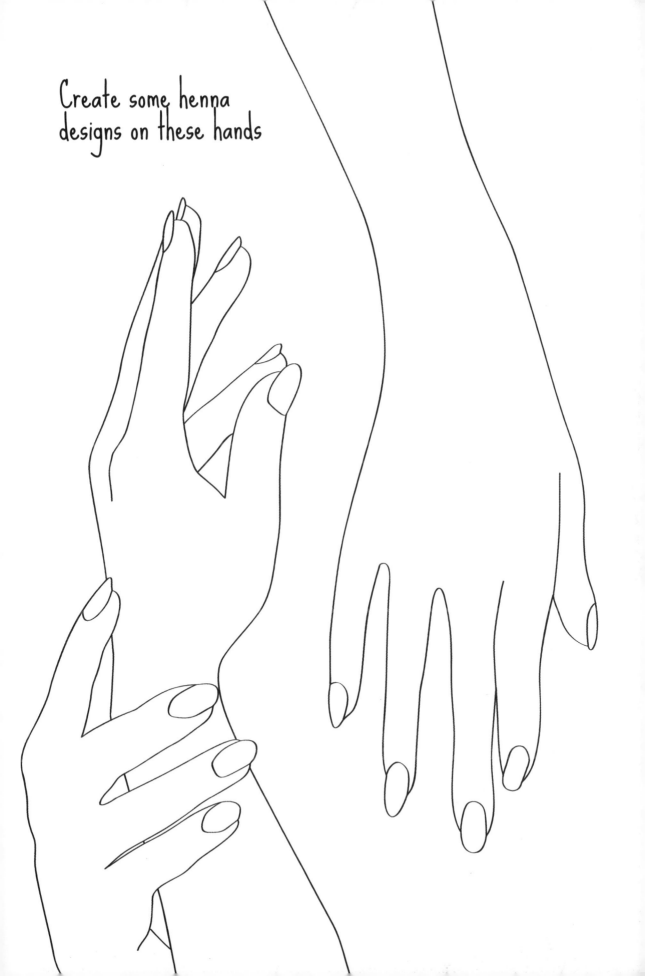

design a kimono that flutters

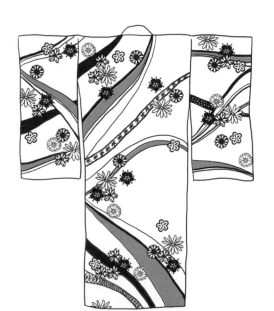

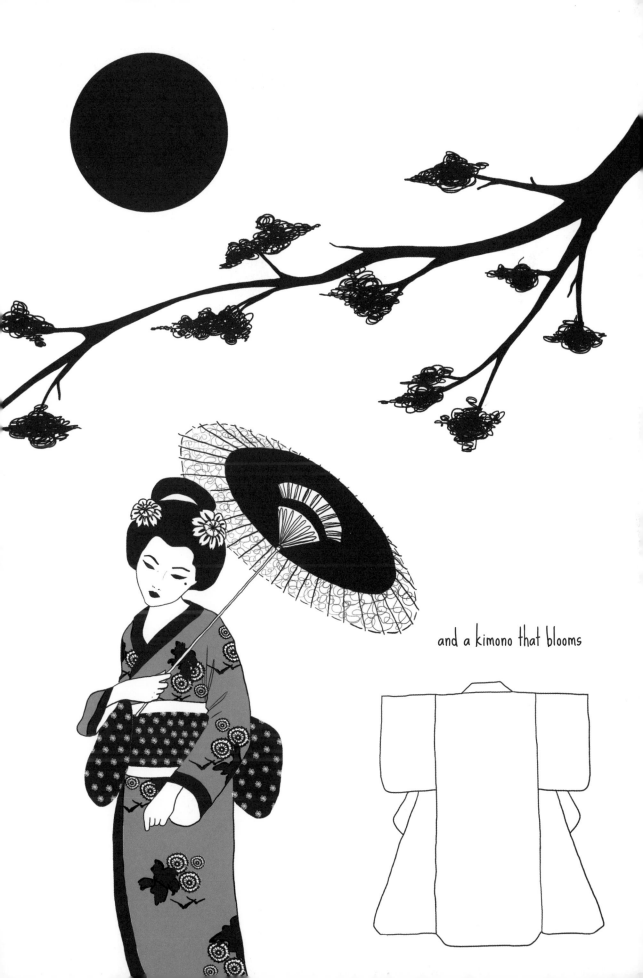

and a kimono that blooms

Draw your DREAMS ✦

Draw your DREAMS